CANADA

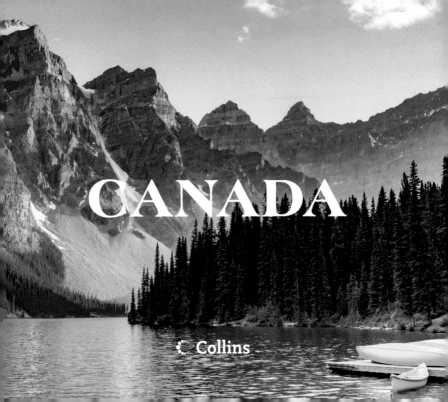

CANADA

Collins

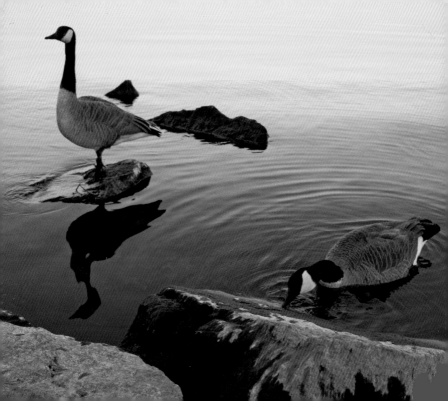

Contents

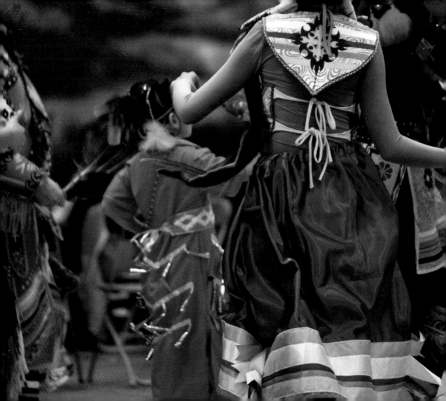

Introduction

"Canada is like an expanding flower—wherever you look you see some fresh petal unrolling." —Sir Arthur Conan Doyle, 1914

Canada, full of natural splendour, is home to some of the world's most incredible mountains, cities, and wilderness areas, and has the longest coastline in the world. A paradise for explorers and photographers, Canada offers endless opportunities to find beauty: from the majesty of the Rocky Mountains to the breadth of the sweeping Prairies to the wonder of the rising sun over the Atlantic Ocean. But the magic of Canada is also found in fishing at one of Canada's many freshwater lakes, discovering the vibrancy of its cities, marvelling at stunning fall colours, and spotting mountain goats snuggling on a snowy ledge.

Bringing together over 250 spectacular images from award-winning photographers for you to explore and enjoy, *Canada* takes you across 5,514 km, from Cape Spear, Newfoundland and Labrador, to Mount Saint Elias in the Yukon, from sea to sea.

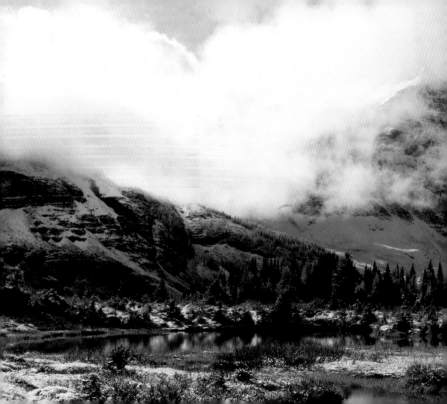

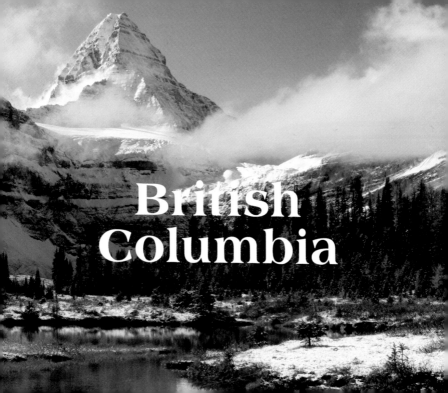

British Columbia

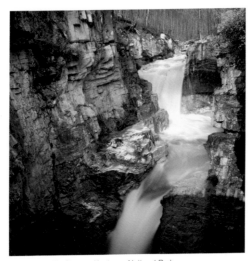

ABOVE: Marble Canyon, Kootenay National Park

RIGHT: Kicking Horse River, Yoho National Park

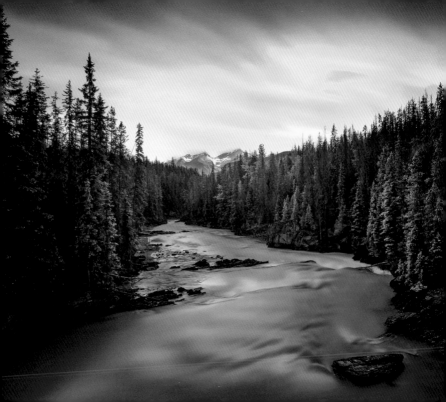

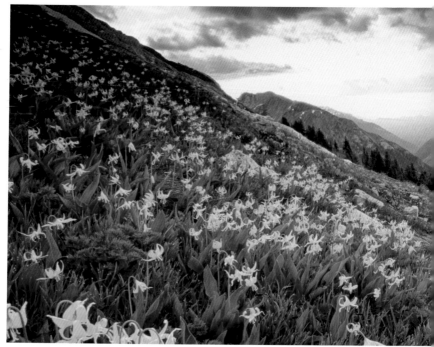

Jumbo Pass in the Purcell Mountains, near Golden

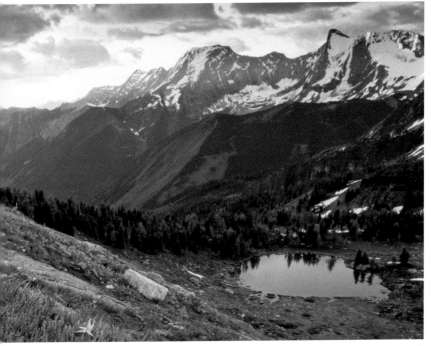

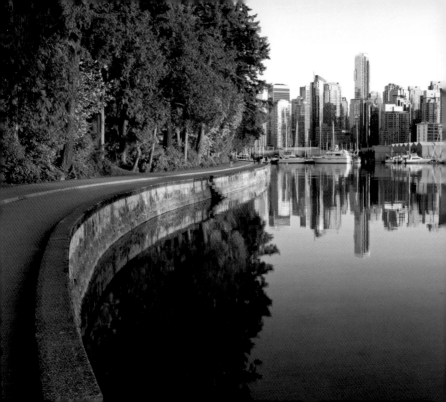

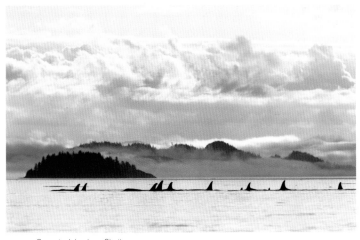

ABOVE: Orcas in Johnstone Strait

LEFT: Stanley Park Seawall and Vancouver skyline

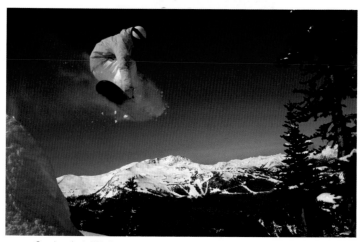

ABOVE: Snowboarder in Whistler

RIGHT: Mount Burgess over Emerald Lake Lodge, Yoho National Park

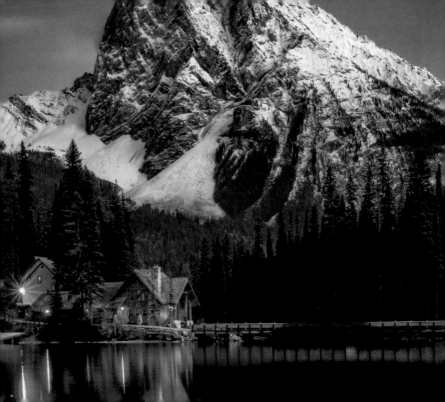

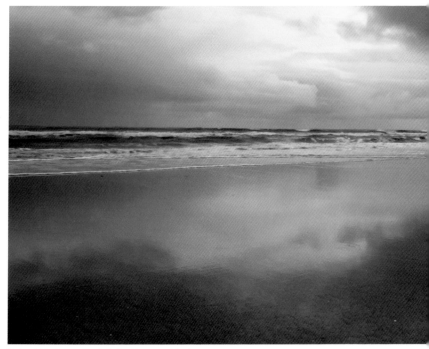

Surfer at Chesterman Beach, Tofino, Vancouver Island

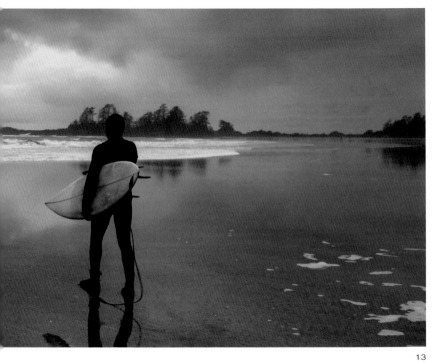

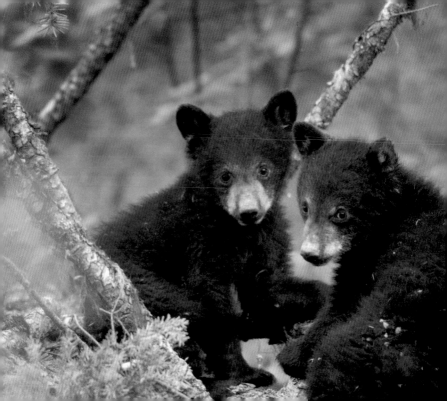

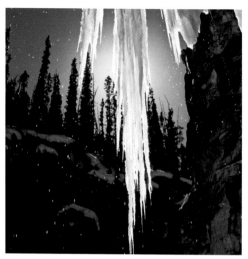

ABOVE: Haffner Creek Falls, Kootenay National Park

LEFT: Black bear cubs in Mount Revelstoke National Park

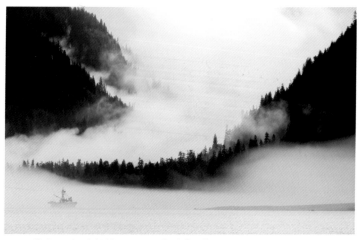

ABOVE: Khutzeymateen Inlet, Khutzeymateen Grizzly Bear Sanctuary

RIGHT: Salmon spawning upstream off of Princess Royal Island

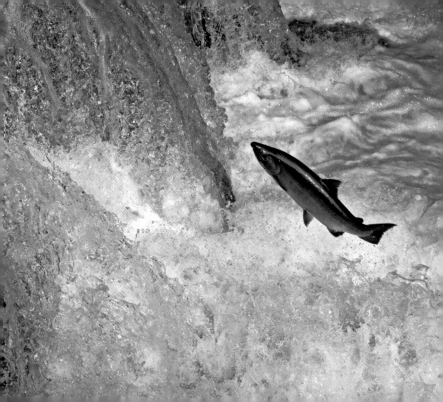

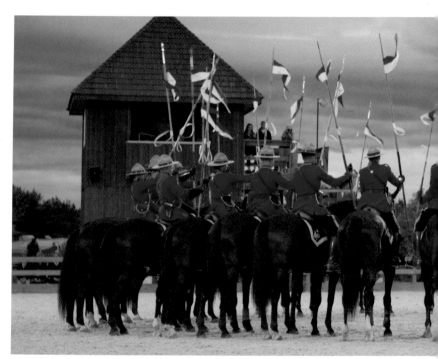

Royal Canadian Mounted Police in Langley

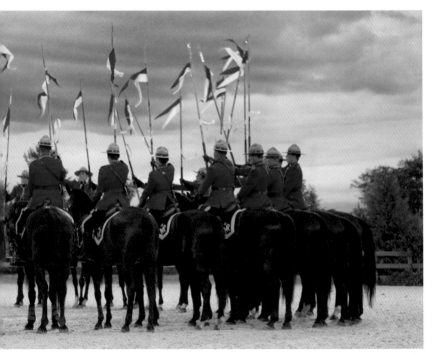

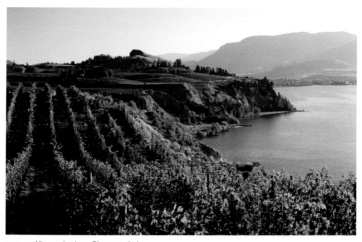

ABOVE: Vineyards along Okanagan Lake

RIGHT: Mount Assiniboine Provincial Park

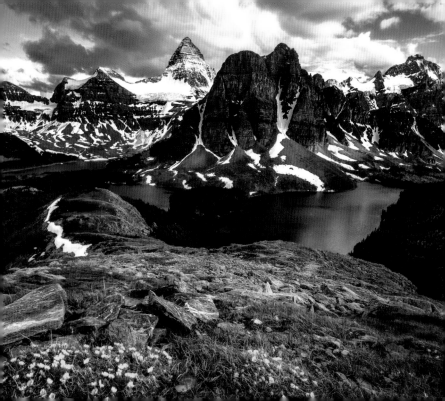

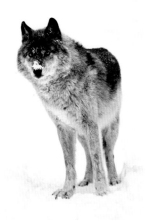

ABOVE: Grey wolf in Golden

RIGHT: Humpback whale in Johnstone Strait

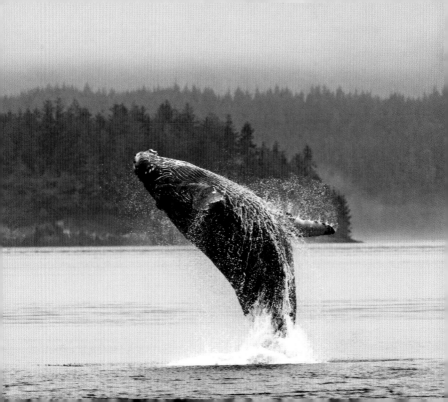

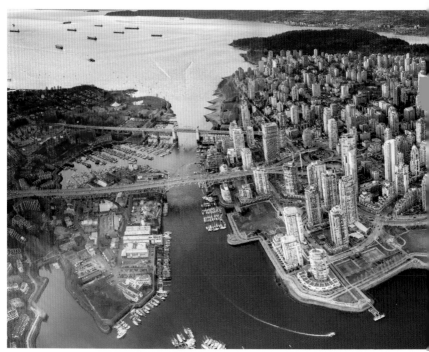

Aerial view of Vancouver

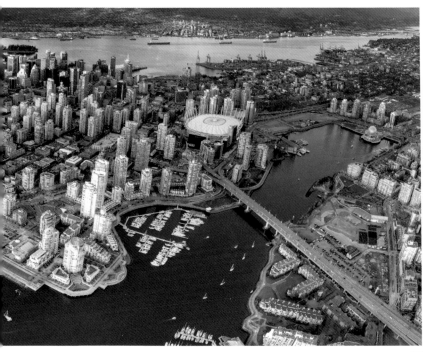

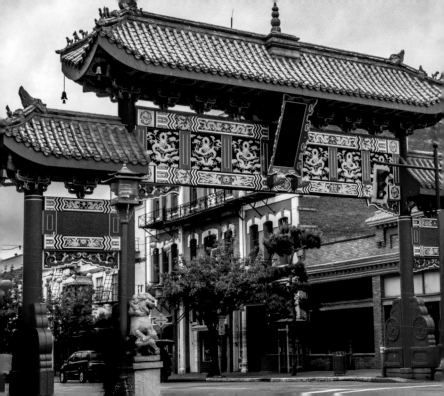

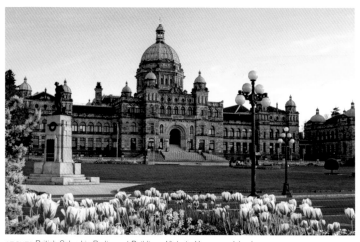

ABOVE: British Columbia Parliament Buildings, Victoria, Vancouver Island

LEFT: Chinatown, Victoria, Vancouver Island

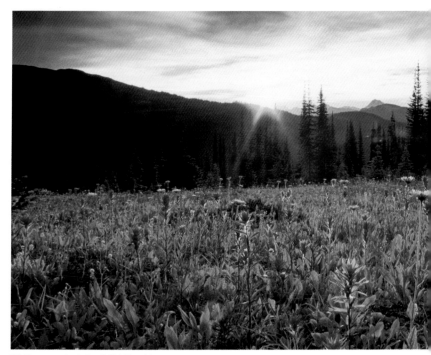

Wildflower meadow in the Selkirk Mountains

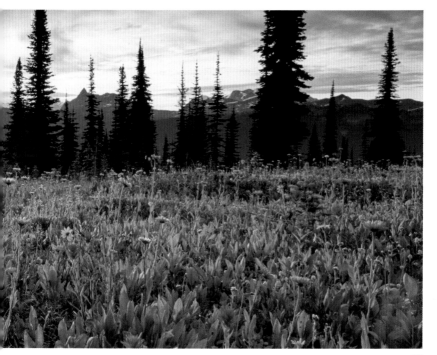

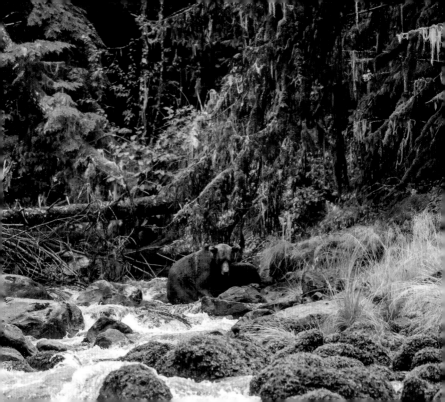

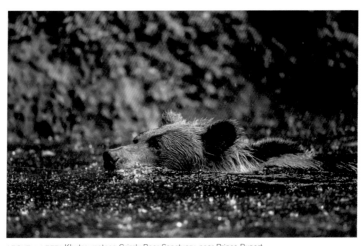

ABOVE & LEFT: Khutzeymateen Grizzly Bear Sanctuary, near Prince Rupert

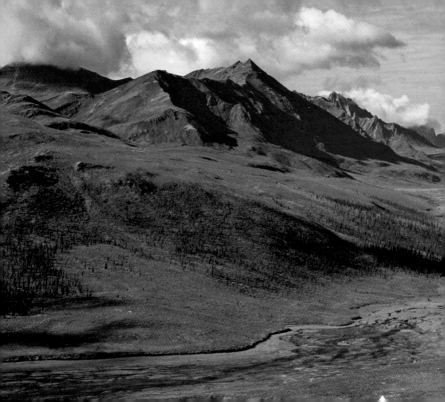

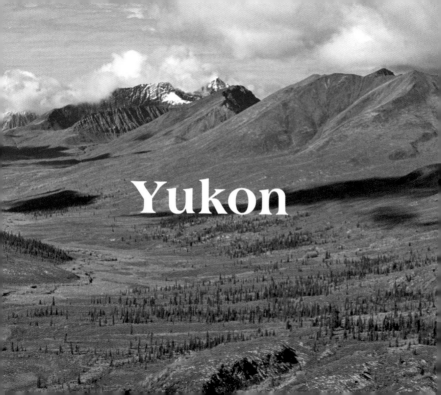

Yukon

ABOVE: Glacial pools at Kaskawulsh Glacier, Saint Elias Mountains

RIGHT: Saint Elias Mountains, Kluane National Park and Reserve

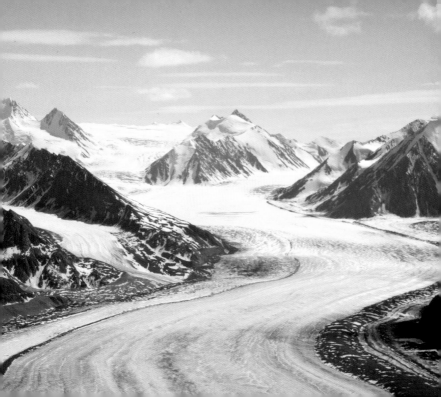

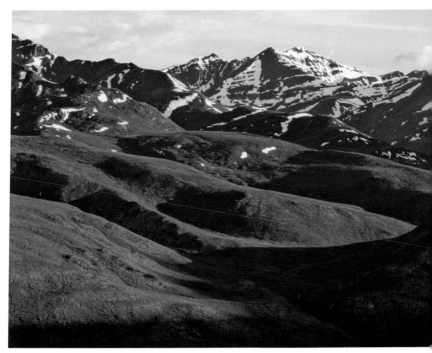

Tombstone Territorial Park

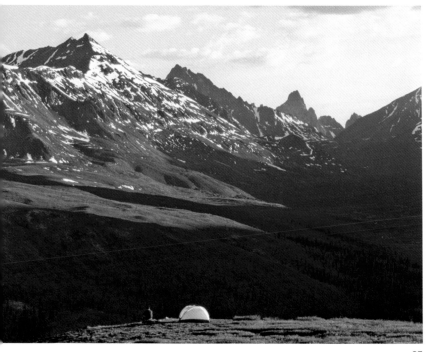

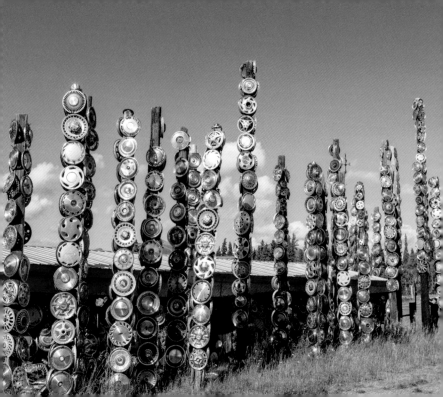

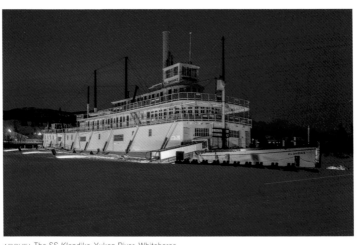

ABOVE: The SS *Klondike*, Yukon River, Whitehorse

LEFT: Hubcap totem poles in Champagne

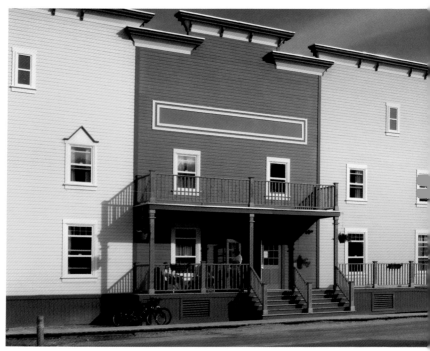

Dawson City

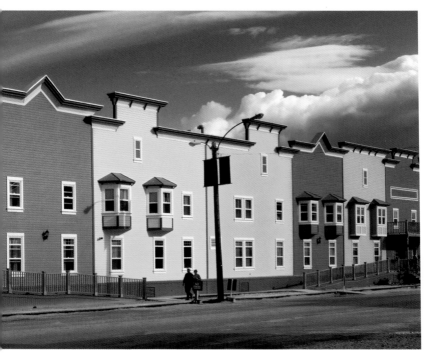

41

Dogsledding in the Yukon

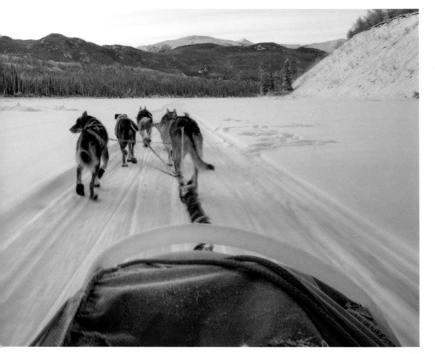

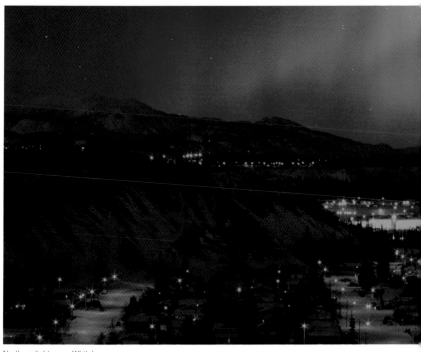

Northern lights over Whitehorse

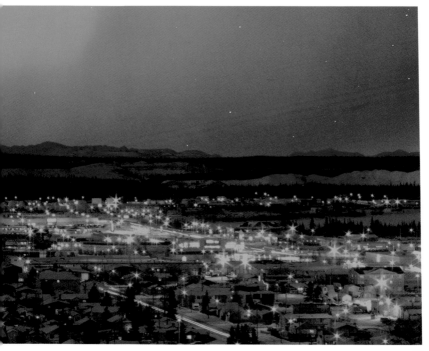

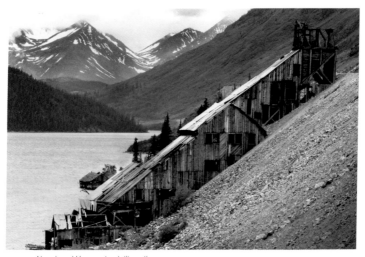

ABOVE: Abandoned Venus mine tailing site

RIGHT: Grizzly bears along the Alaska Highway

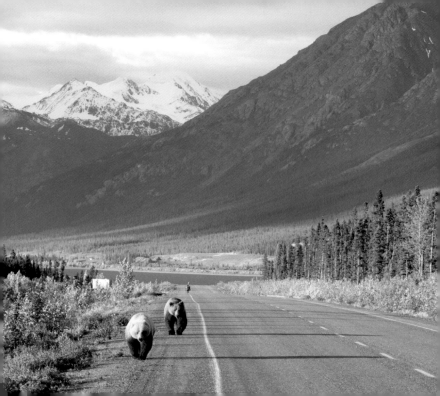

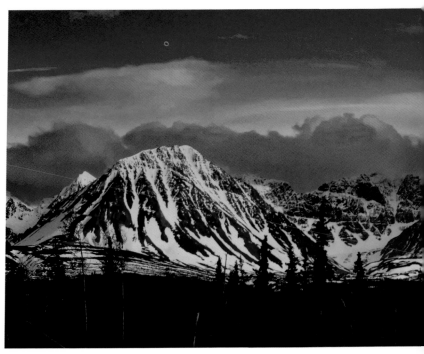

Kluane National Park and Reserve

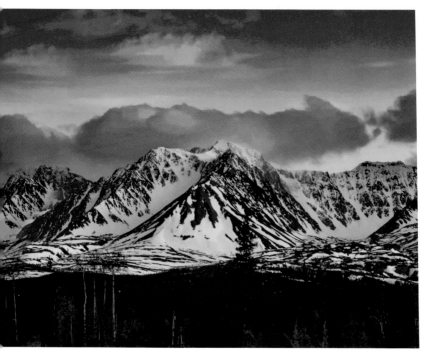

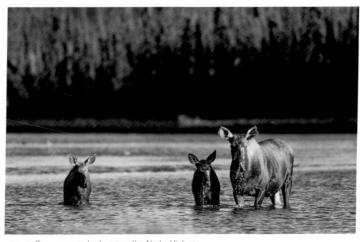

ABOVE: Cow moose and calves near the Alaska Highway

RIGHT: North Fork Klondike River Valley, Tombstone Territorial Park

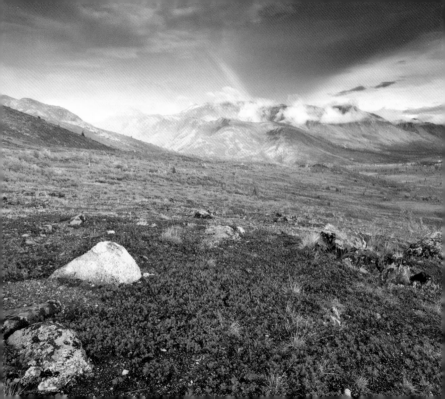

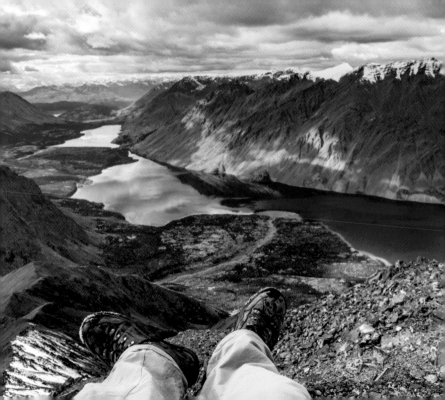

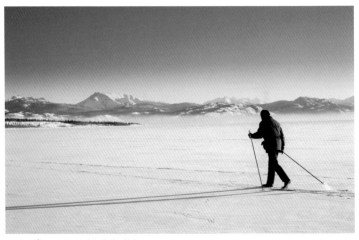

ABOVE: Cross-country skier in the Yukon

LEFT: Resting atop a Yukon mountain range

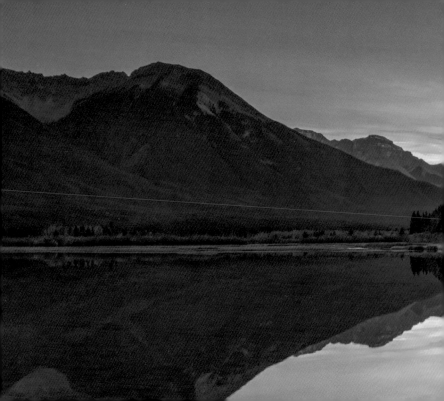

Alberta

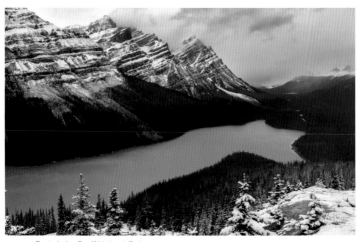

ABOVE: Peyto Lake, Banff National Park

RIGHT: Trans-Canada Highway near Calgary

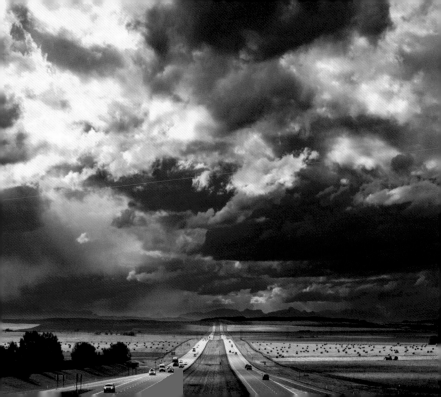

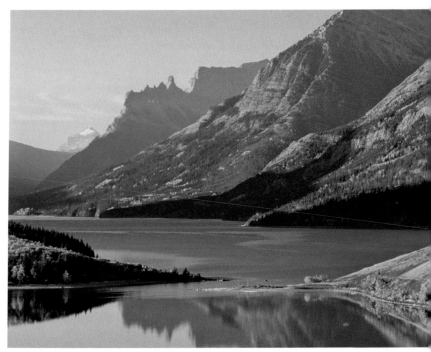
Prince of Wales Hotel, Waterton Lakes National Park

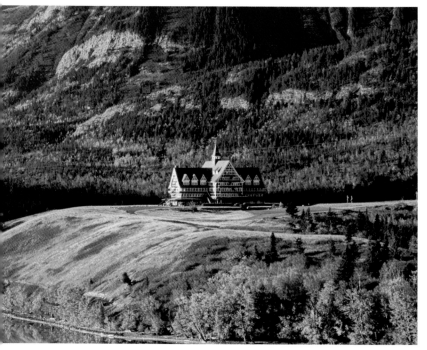

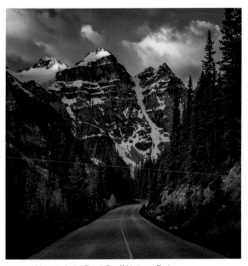

ABOVE: Moraine Lake Road, Banff National Park

RIGHT: Camping at Moraine Lake, Banff National Park

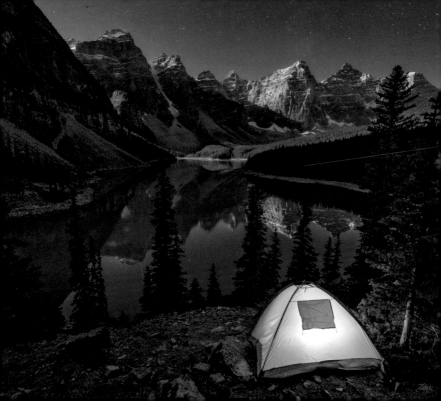

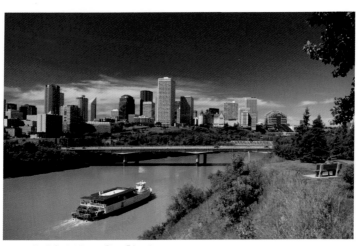

ABOVE: North Saskatchewan River, Edmonton

RIGHT: Bow River, Calgary

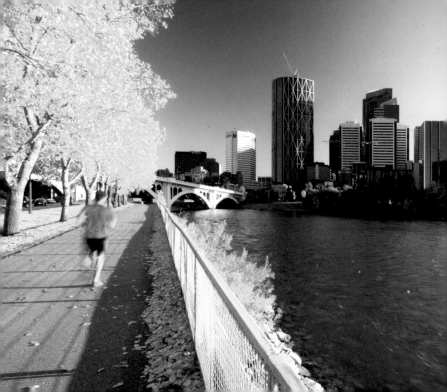

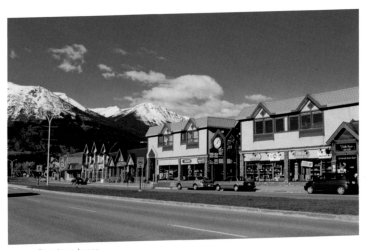

ABOVE: Downtown Jasper

RIGHT: Cattle drive near Calgary

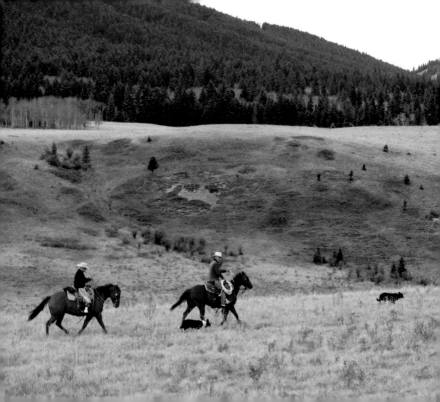

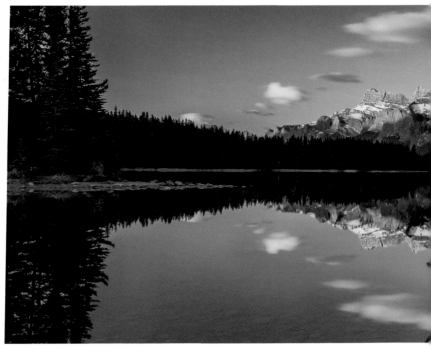

Mount Rundle, Banff National Park

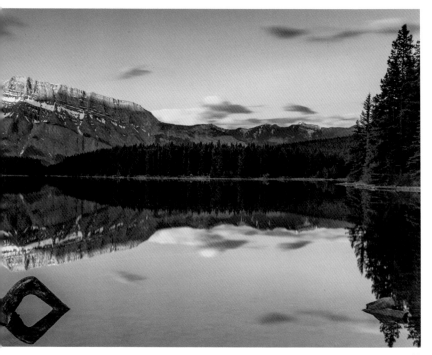

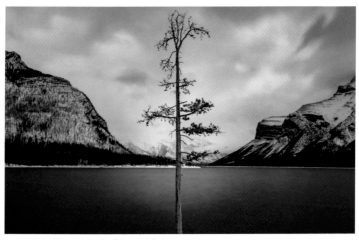

ABOVE: Lake Minnewanka, Banff National Park

RIGHT: Morant's Curve, Canadian Pacific Railway, Bow Valley Parkway

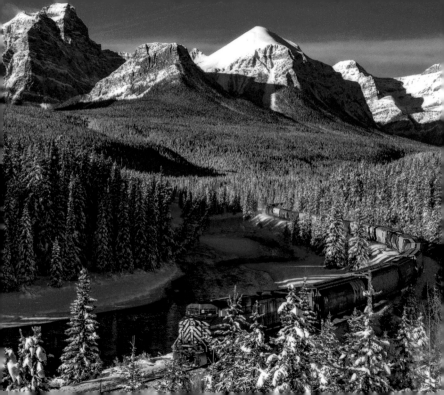

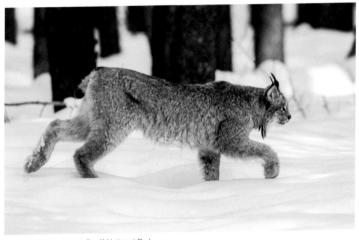

ABOVE: Canada lynx in Banff National Park

RIGHT: Mountain goat nanny and kid in Jasper National Park

70

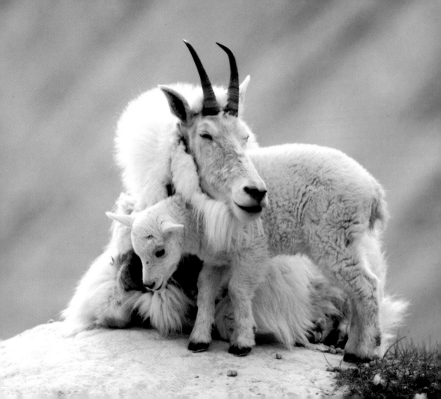

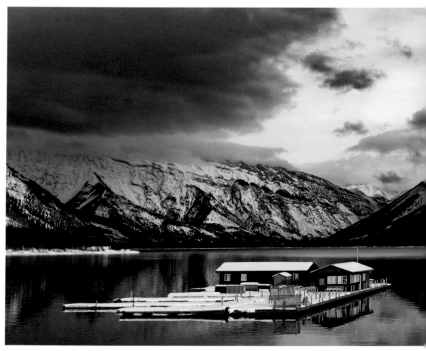

Lake Minnewanka, Banff National Park

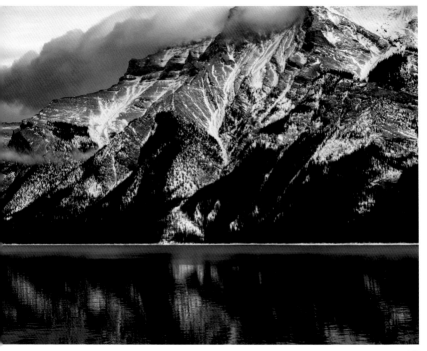

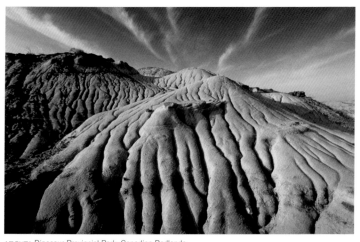

ABOVE: Dinosaur Provincial Park, Canadian Badlands

RIGHT: Castle Mountain and the Bow River, Banff National Park

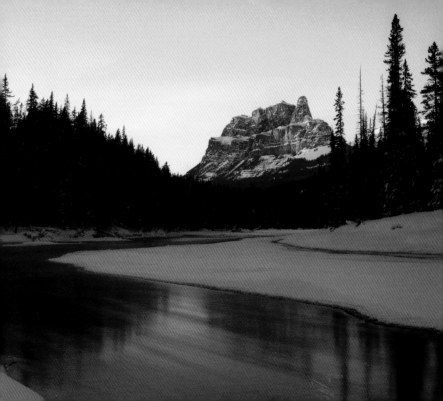

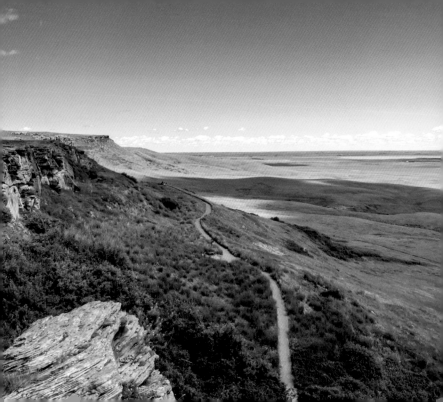

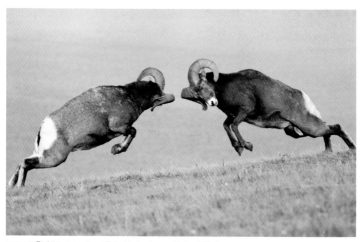

ABOVE: Bighorn rams above Talbot Lake, Jasper National Park

LEFT: Head-Smashed-In Buffalo Jump World Heritage Site

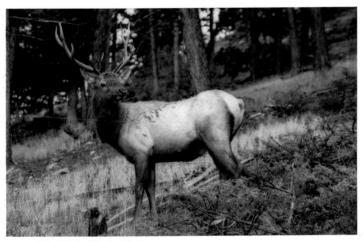

ABOVE: Male elk in Banff National Park

RIGHT: Herd of cow elk on the David Thompson Highway

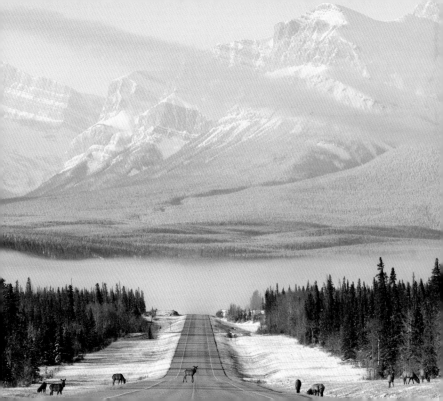

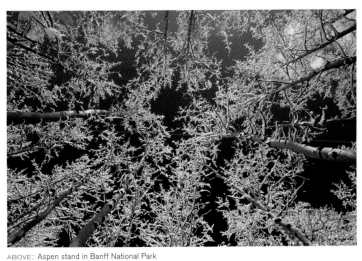

ABOVE: Aspen stand in Banff National Park

RIGHT: Chateau Lake Louise, Banff National Park

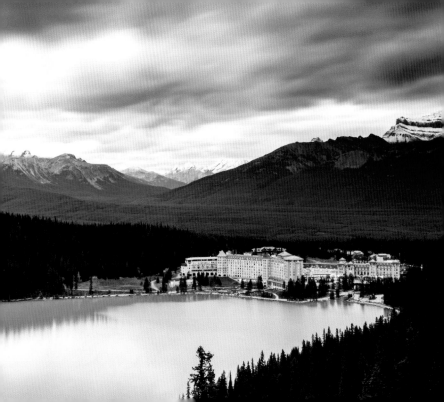

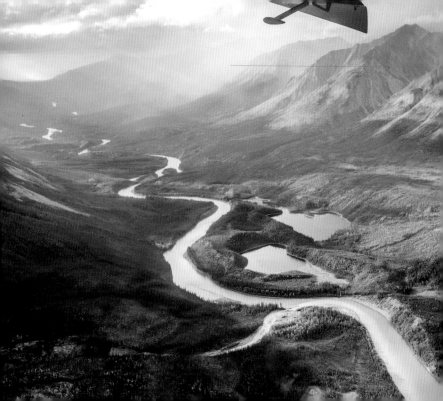

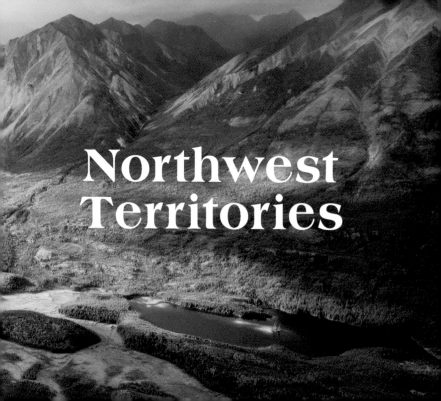

Northwest
Territories

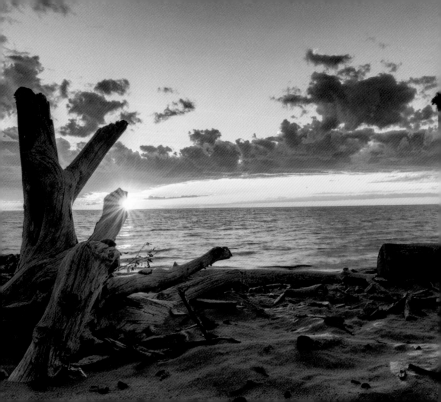

Vale Island, Hay River

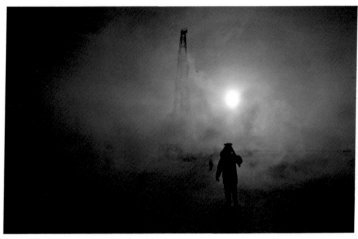

ABOVE: Oil detection site near Lougheed Island

RIGHT: Death Lake, Nahanni National Park Reserve

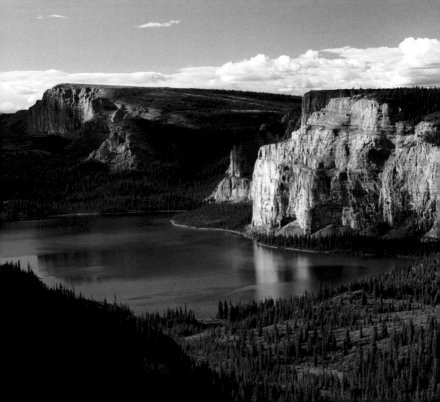

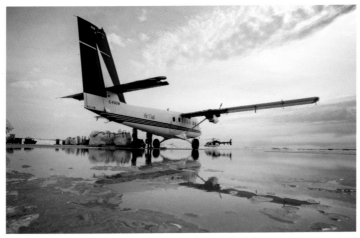

ABOVE: Cargo plane at the Kennady Diamonds' Kelvin Camp in Yellowknife

RIGHT: Herd of bull muskoxen on Banks Island

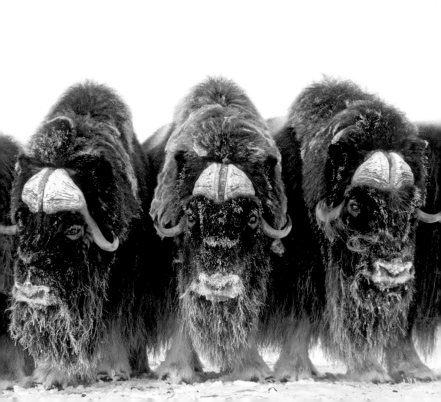

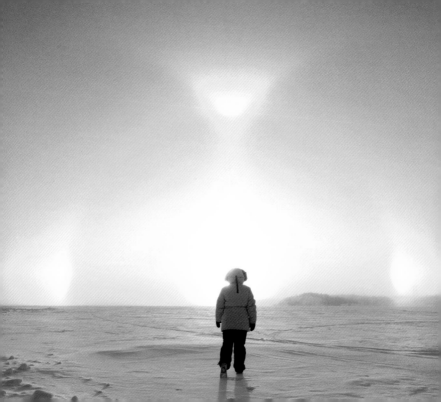

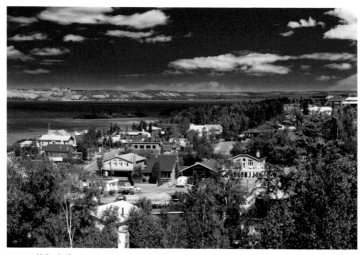

ABOVE: Yellowknife

LEFT: Sun dog optical phenomenon on Great Slave Lake, Yellowknife

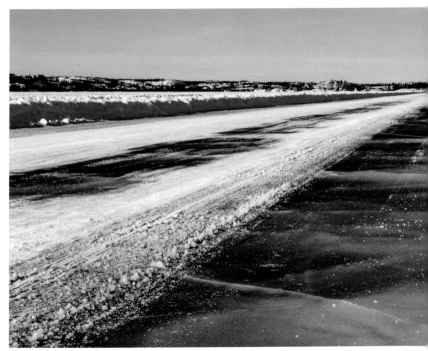

Dettah Ice Road, Great Slave Lake

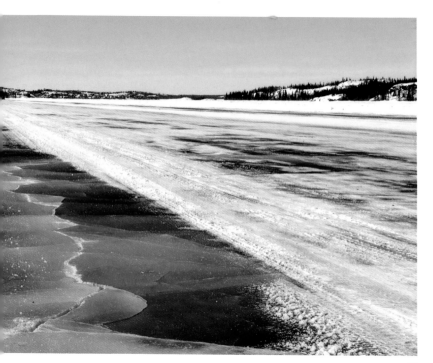

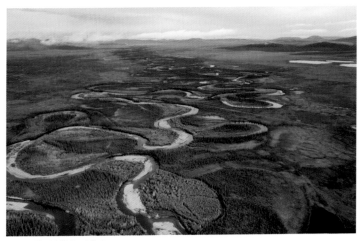

ABOVE: Vuntut National Park

RIGHT: Wood bison

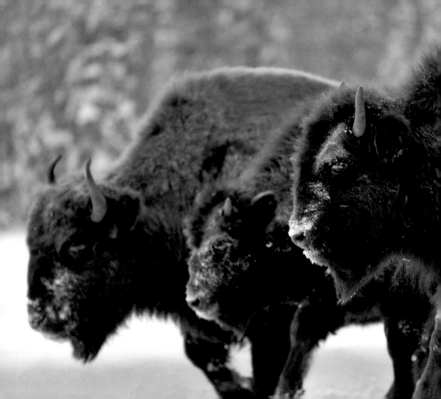

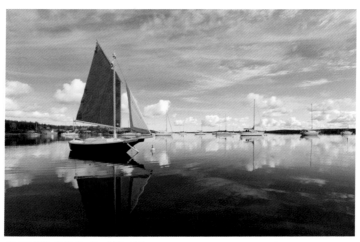

ABOVE: Yellowknife Bay, Great Slave Lake

RIGHT: Alexandra Falls, Hay River

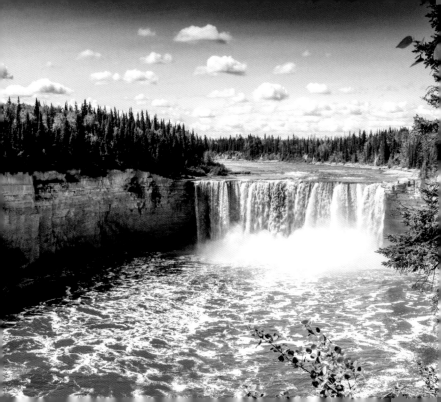

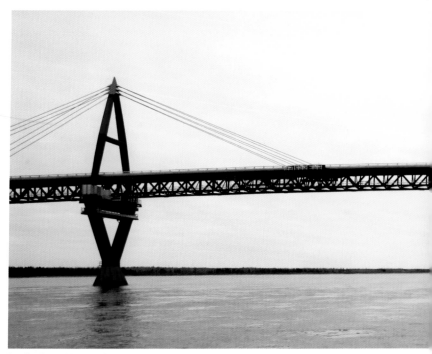

Deh Cho Bridge, Mackenzie River

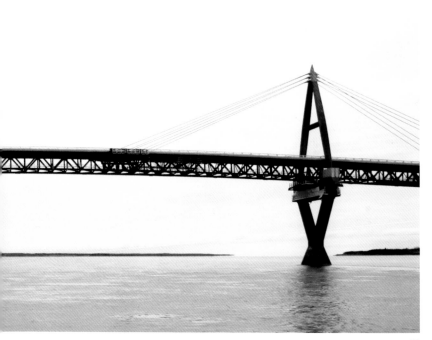

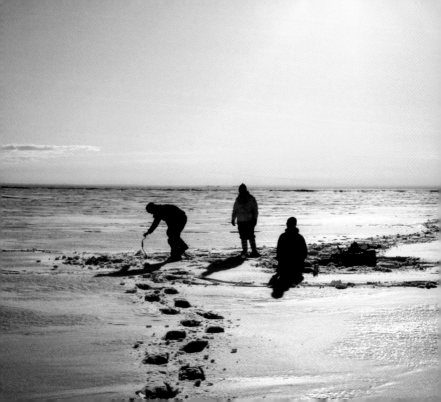

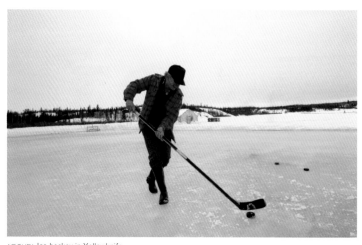

ABOVE: Ice hockey in Yellowknife

LEFT: Ice fishing in Great Slave Lake, Yellowknife

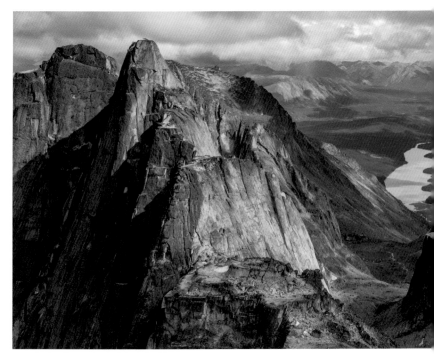

Cirque of the Unclimbables, Nahanni National Park Reserve

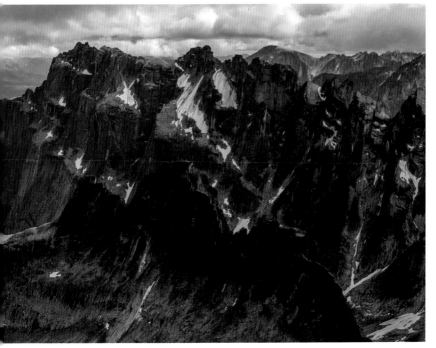

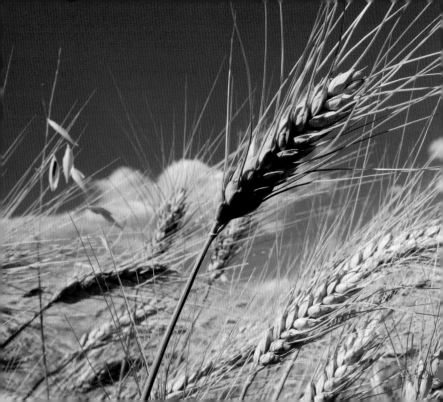

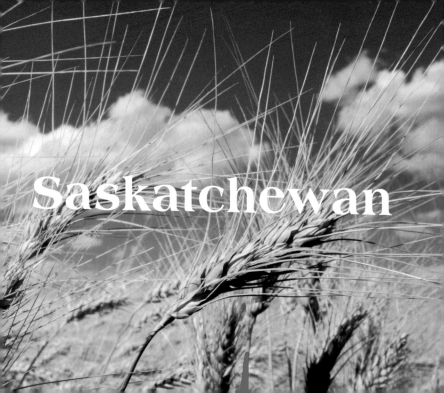

ABOVE: Grasslands National Park

RIGHT: Trans-Canada Highway near Moosejaw

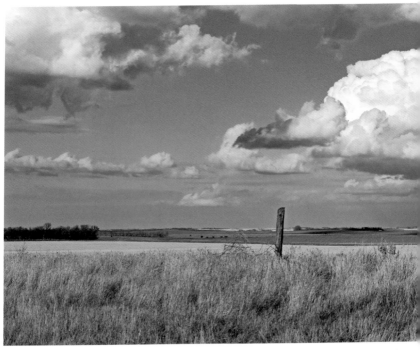

Hanley

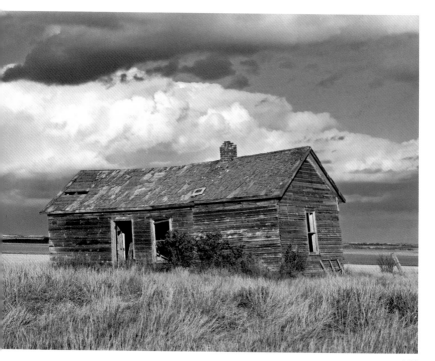

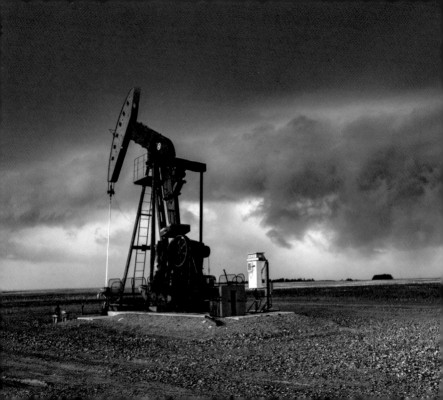

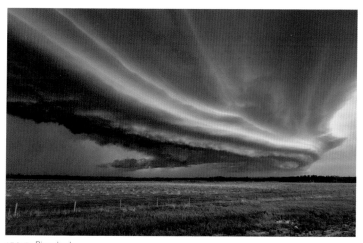

ABOVE: Pierceland

LEFT: Pumpjack near Carlyle

St. John the Baptist Ukrainian Catholic Church
in the ghost town of Smuts

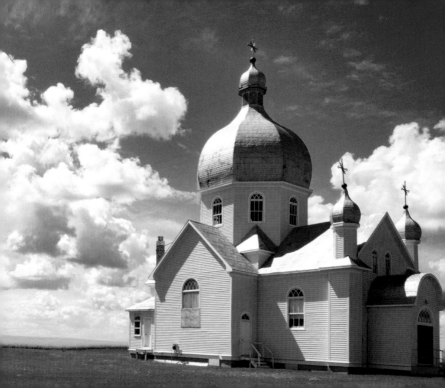

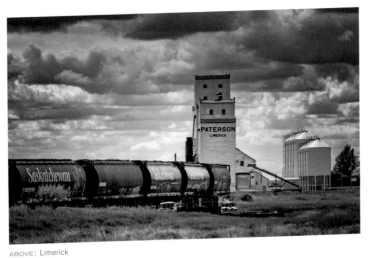

ABOVE: Limerick

RIGHT: Kenaston

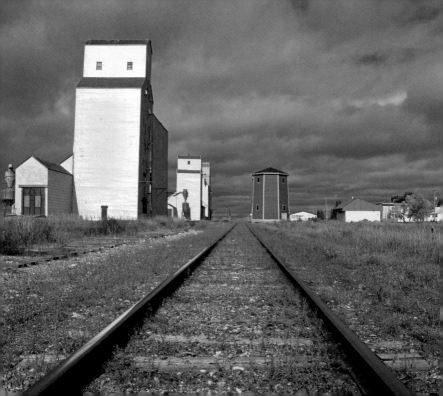

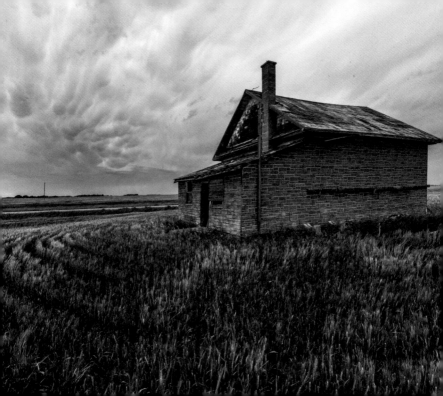

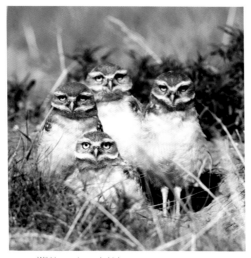

ABOVE: Wild burrowing owl chicks

LEFT: Avonhurst

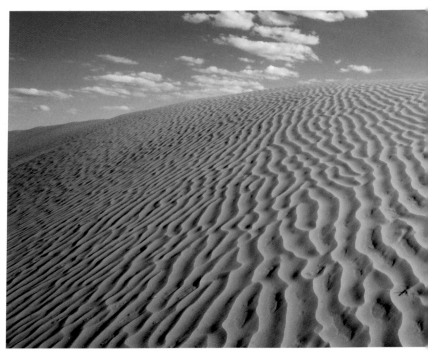

Great Sandhills Ecological Reserve

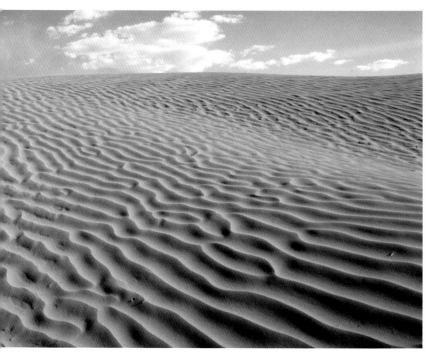

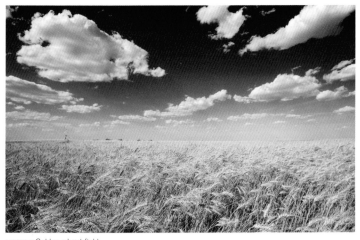

ABOVE: Golden wheat field

RIGHT: Pronghorns in southeastern Saskatchewan

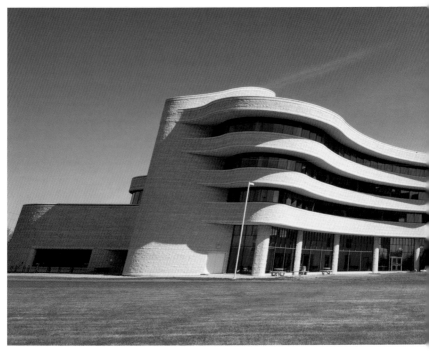

First Nations University of Canada, Regina

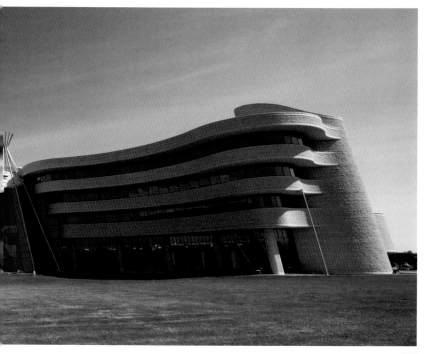

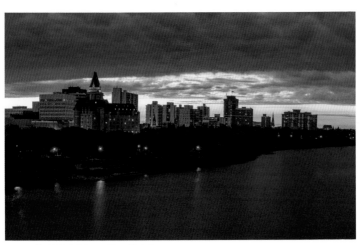

ABOVE: South Saskatchewan River, Saskatoon

RIGHT: Walter Scott Memorial and Saskatchewan Legislative Building, Regina

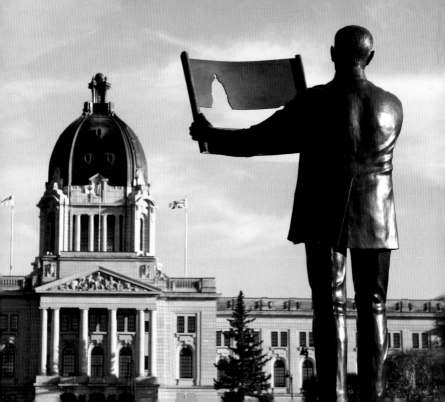

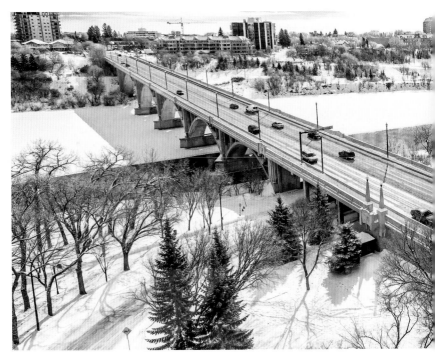

Broadway and Victoria Bridges, Meewasin Valley, Saskatoon

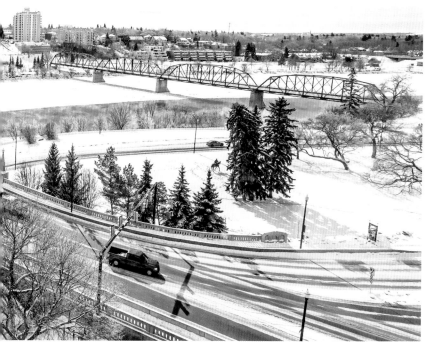

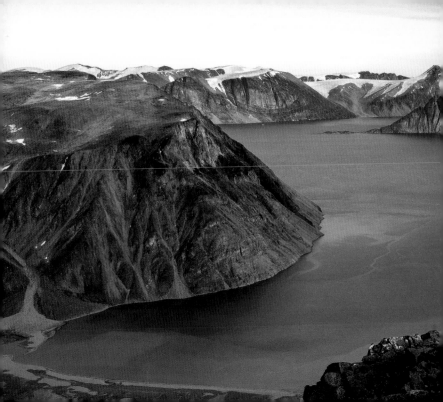

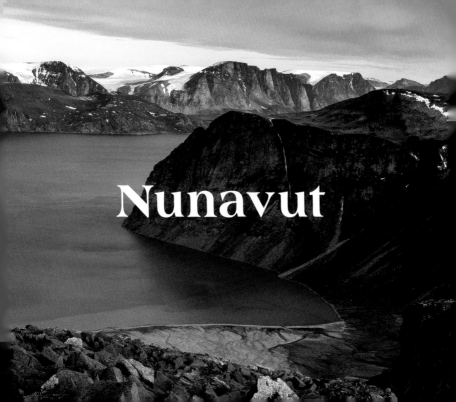

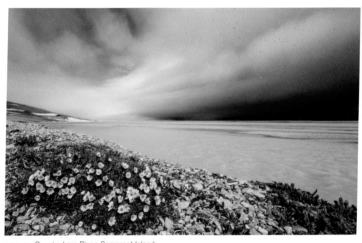

ABOVE: Cunningham River, Somerset Island

RIGHT: Arctic foxes on Somerset Island

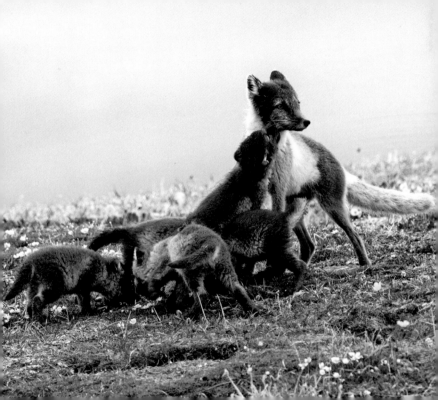

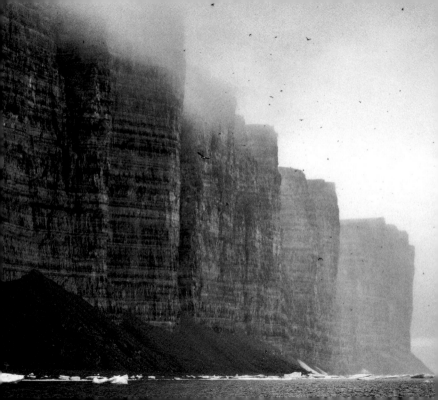

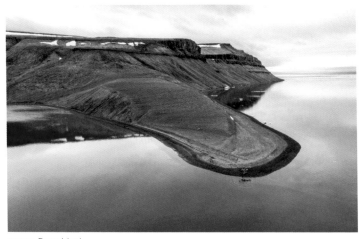

ABOVE: Devon Island

LEFT: Auks flying by Somerset Island

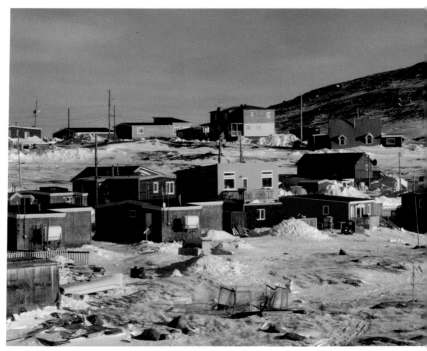

Apex, Iqaluit

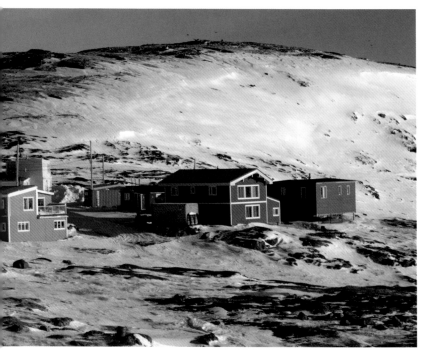

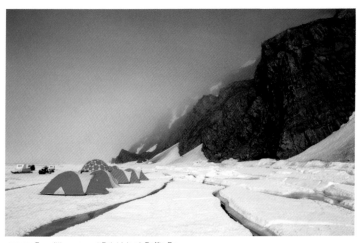

ABOVE: Expedition camp at Bylot Island, Baffin Bay

RIGHT: Iceberg near Bylot Island, Baffin Bay

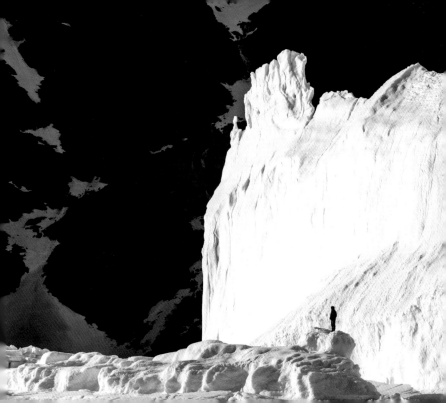

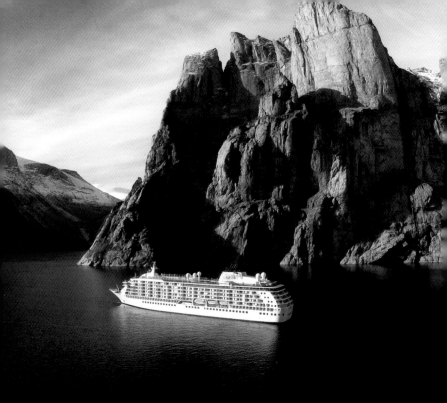

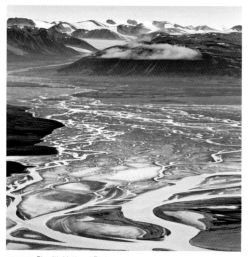

ABOVE: Sirmilik National Park

LEFT: Sam Ford Fjord, Baffin Island

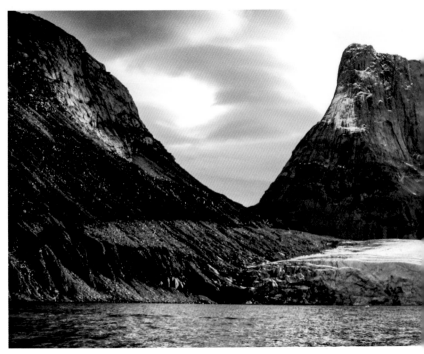

Sam Ford Fjord, Baffin Island

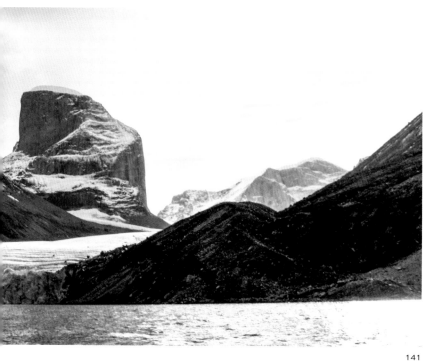

ABOVE: Pangnirtung

RIGHT: Iqaluit International Airport Terminal

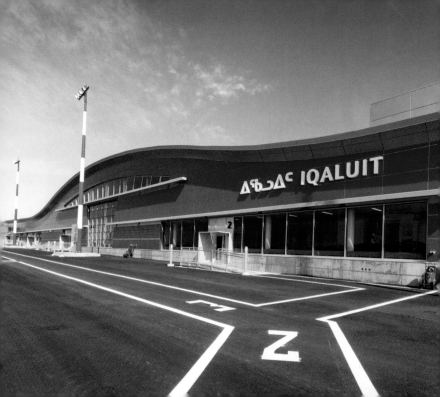

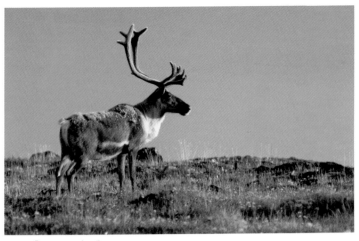

ABOVE: Barren-ground caribou

RIGHT: Iceberg near Qikiqtarjuaq Village, Baffin Island

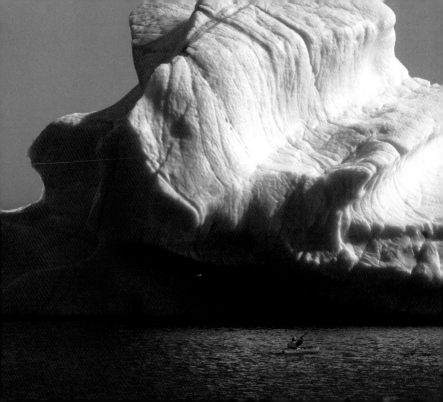

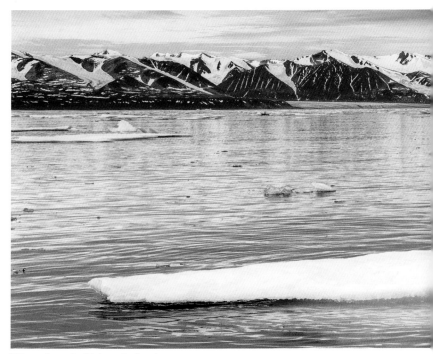

Walrus mother and calf in Lancaster Sound

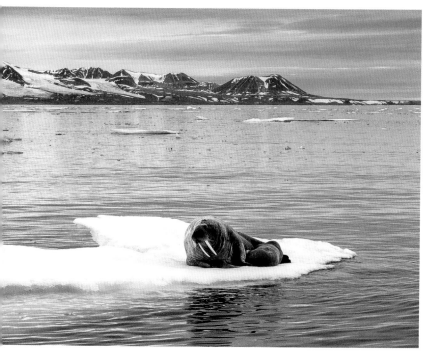

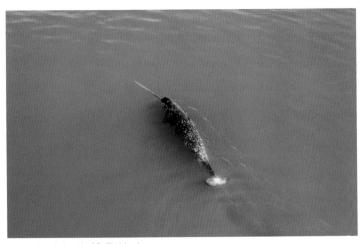

ABOVE: Narwhal north of Baffin Island

RIGHT: Beluga whale pod off of Port Leopold, Somerset Island

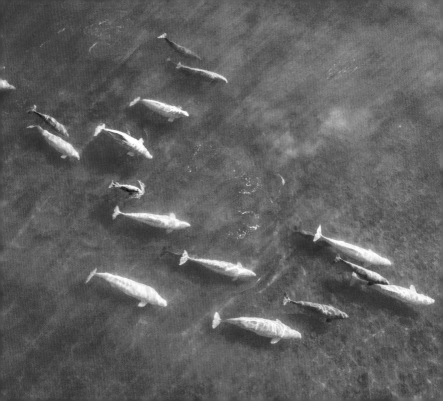

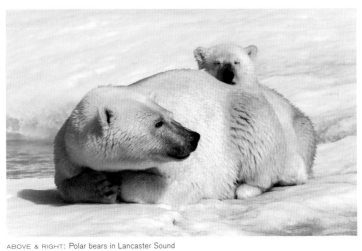

ABOVE & RIGHT: Polar bears in Lancaster Sound

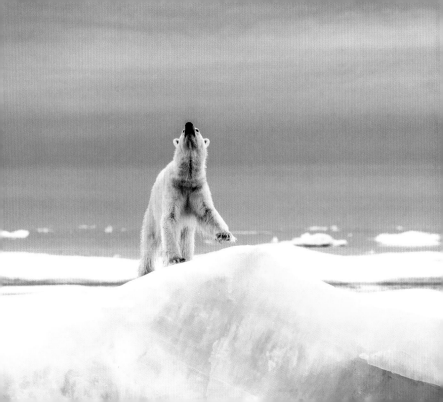

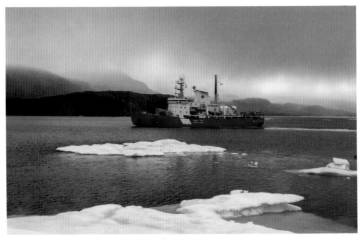

ABOVE: Canadian Coast Guard ship in Bellot Strait

RIGHT: Polar bear in Tremblay Sound

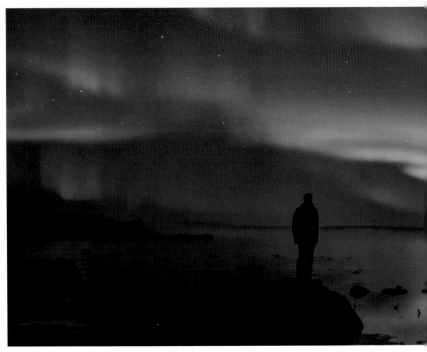
Northern lights over Ennadai Lake

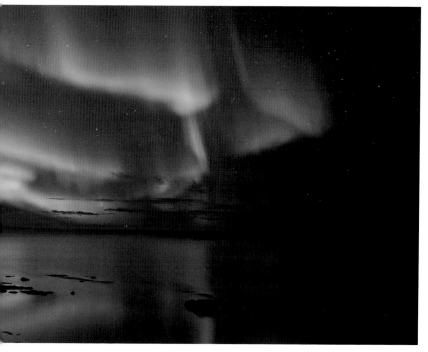

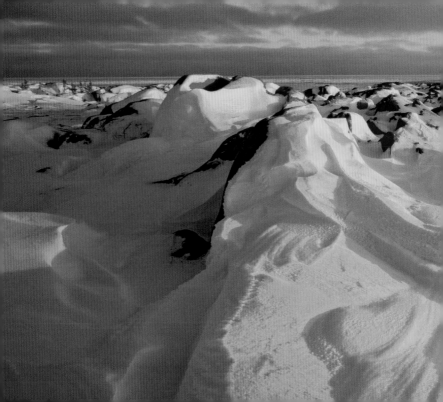

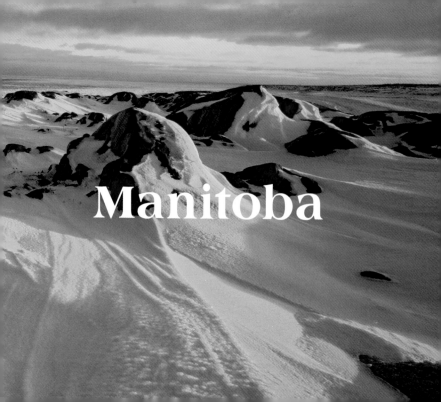

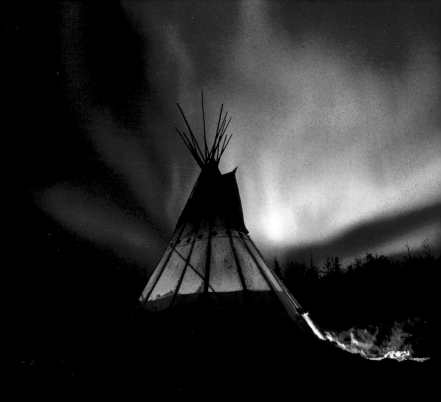

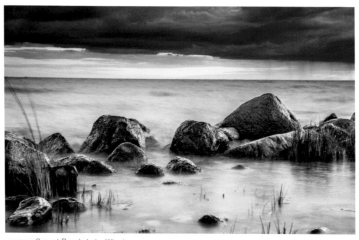

ABOVE: Sunset Beach, Lake Winnipeg

LEFT: Teepee in Churchill

ABOVE & RIGHT: Canadian Museum for Human Rights, Winnipeg

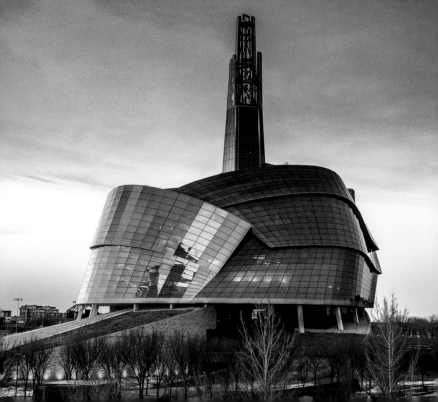

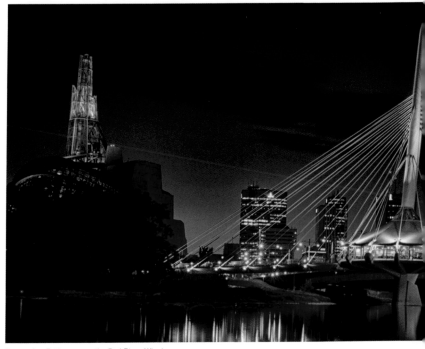

Provencher Bridge across the Red River, Winnipeg

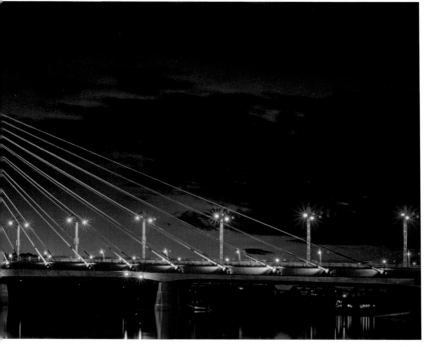

163

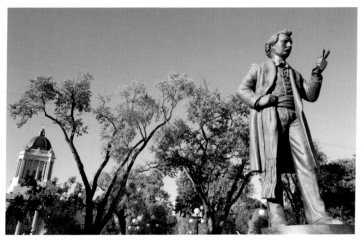

ABOVE: Manitoba Legislative Building and Louis Riel statue, Winnipeg

RIGHT: Royal Canadian Mint, Winnipeg

164

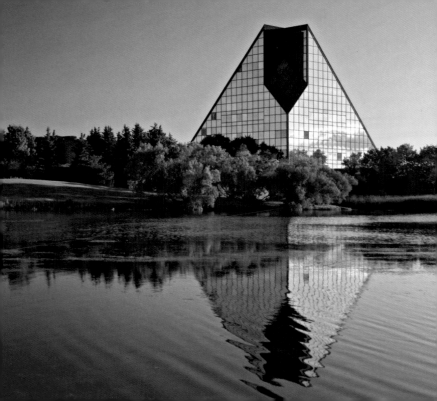

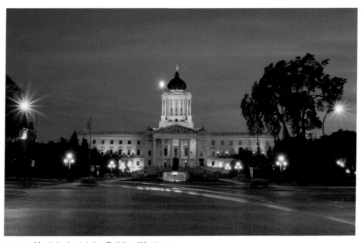

ABOVE: Manitoba Legislative Building, Winnipeg

RIGHT: Grain elevator in Carey

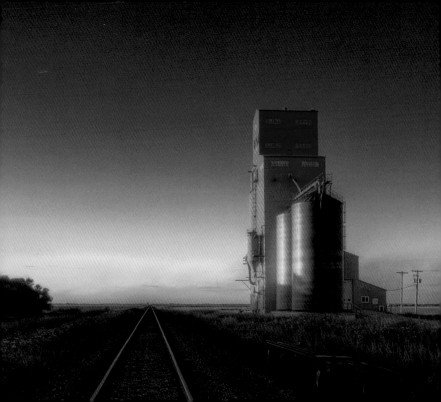

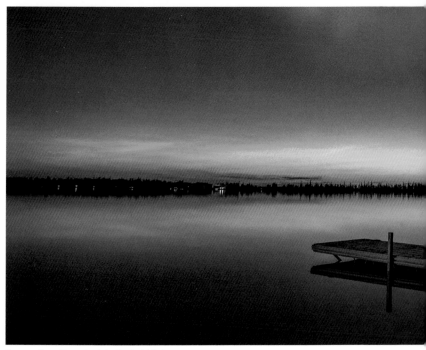

Campers Cove, Clearwater Lake Provincial Park

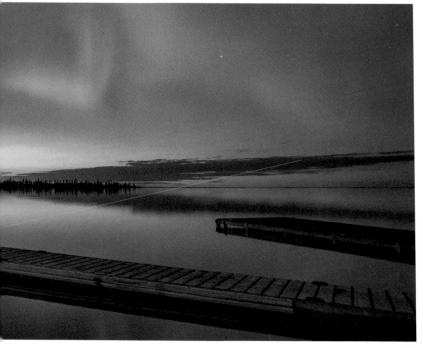

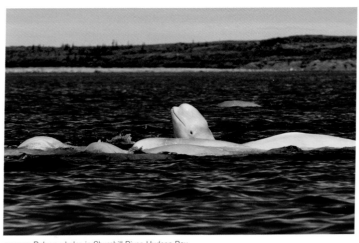

ABOVE: Beluga whales in Churchill River, Hudson Bay

RIGHT: Polar bear and Tundra Buggy in Churchill

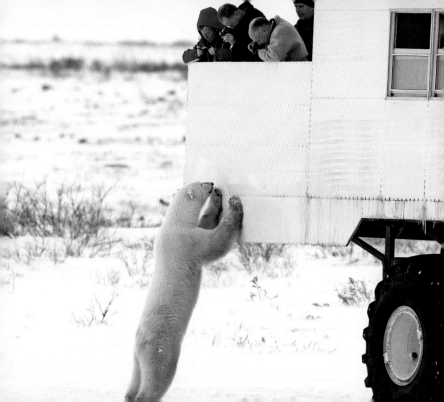

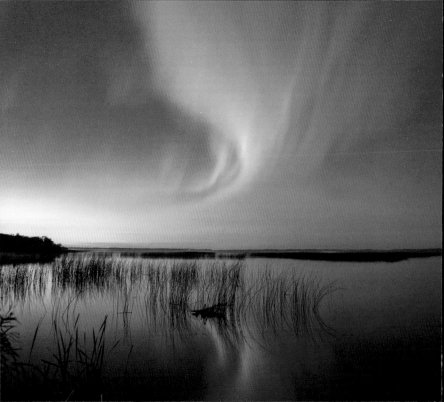

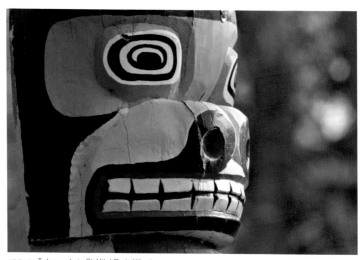

ABOVE: Totem pole in St. Vital Park, Winnipeg

LEFT: Northern lights in The Pas

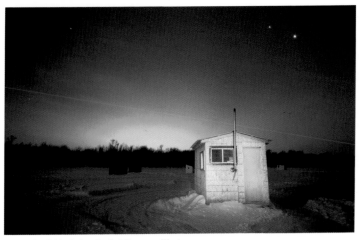

ABOVE: Ice fishing hut on the Red River, near Winnipeg

RIGHT: Arctic fox on the frozen coast of Hudson Bay, near Churchill

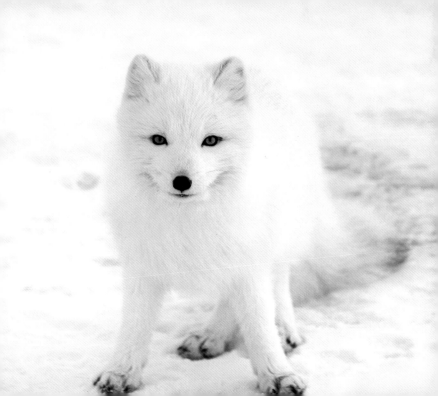

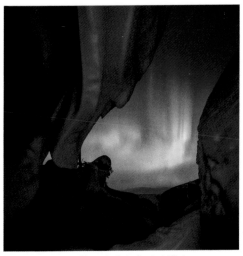

ABOVE: The caves at Clearwater Lake Provincial Park

RIGHT: Northern lights in Churchill

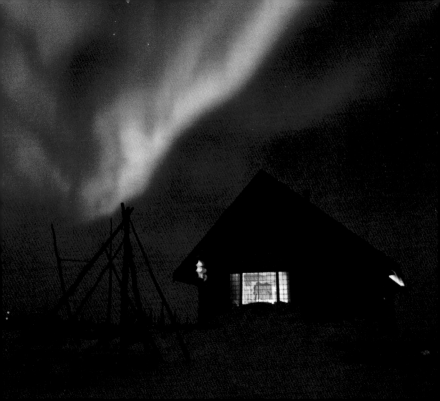

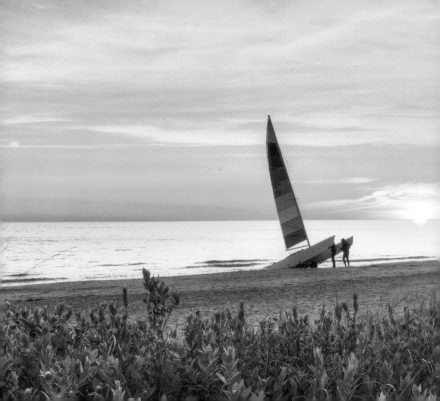

Ontario

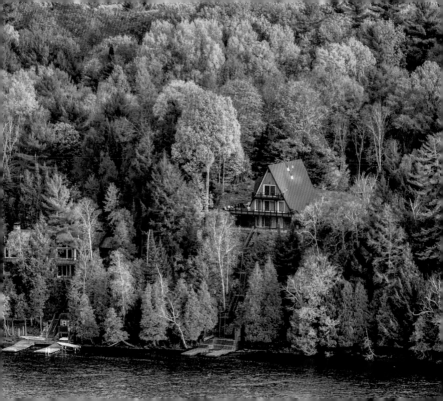

ABOVE: Lake of Bays, Muskoka

LEFT: Dorset, Muskoka

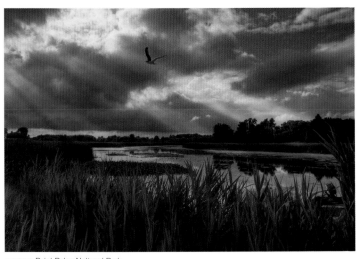

ABOVE: Point Pelee National Park

RIGHT: View from the Top of the Giant, Lake Superior, Thunder Bay

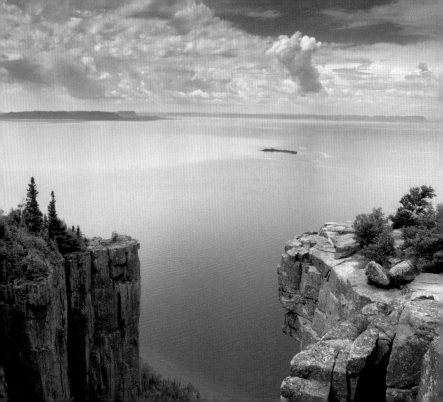

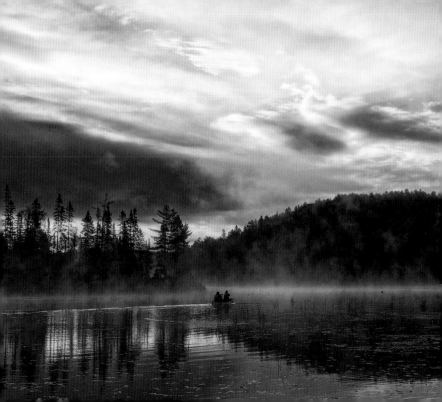

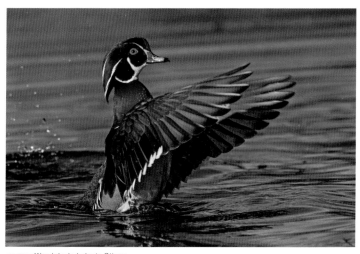

ABOVE: Wood duck drake in Ottawa

LEFT: Costello Lake, Algonquin Provincial Park

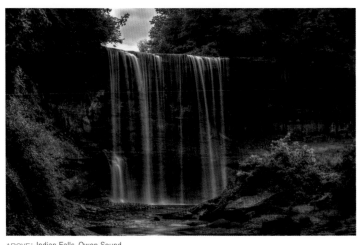

ABOVE: Indian Falls, Owen Sound

RIGHT: Horseshoe Falls, Niagara Falls

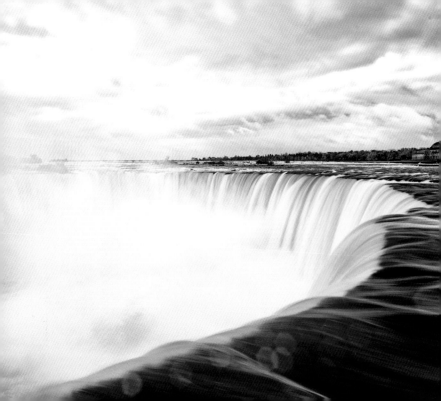

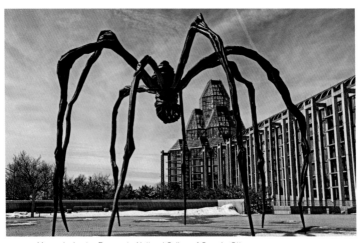

ABOVE: *Maman* by Louise Bourgeois, National Gallery of Canada, Ottawa

RIGHT: Peace Tower, Parliament Hill, Ottawa

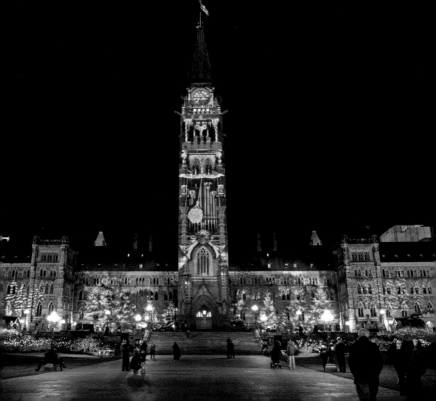

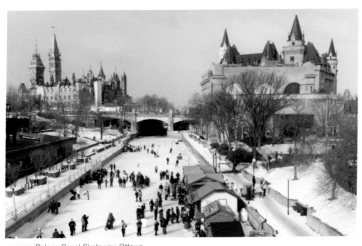

ABOVE: Rideau Canal Skateway, Ottawa

RIGHT: Central Chambers, Ottawa

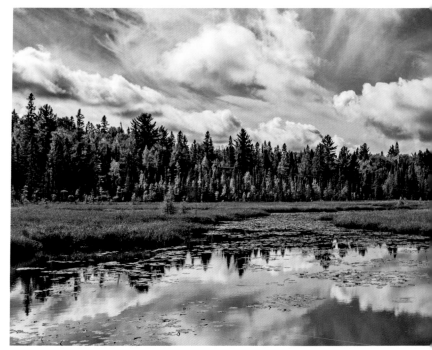

Mizzy Lake Trail, Algonquin Provincial Park

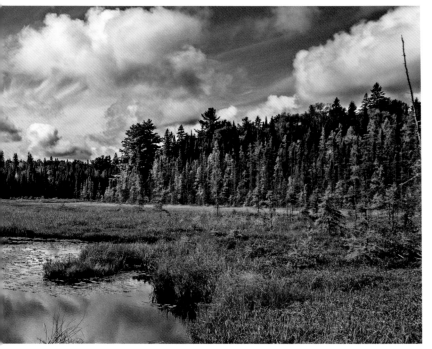

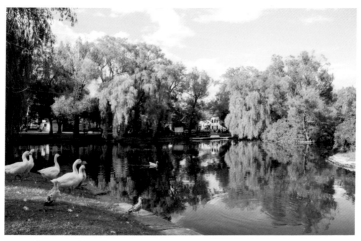

ABOVE: Centre Island, Toronto

RIGHT: Cherry blossoms in High Park, Toronto

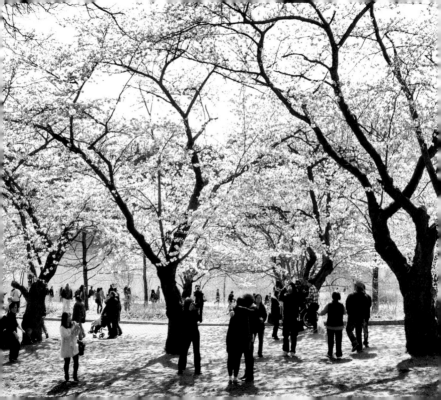

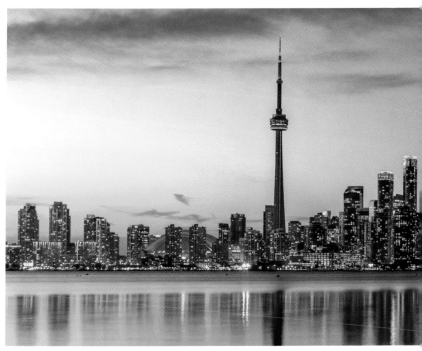
Toronto skyline

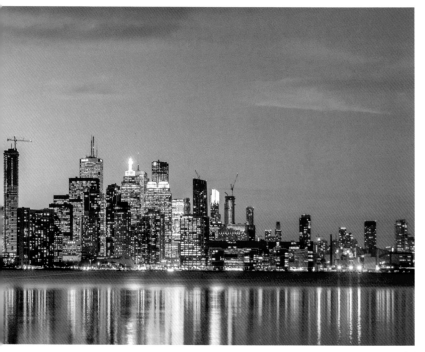

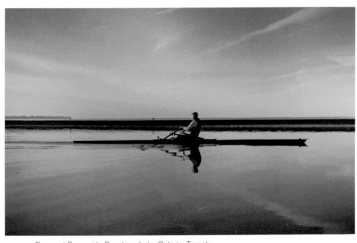

ABOVE: Rower at Sunnyside Beach on Lake Ontario, Toronto

RIGHT: Fu Yao Supermarket, East Chinatown, Toronto

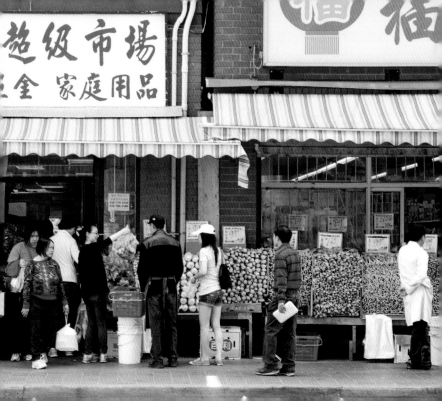

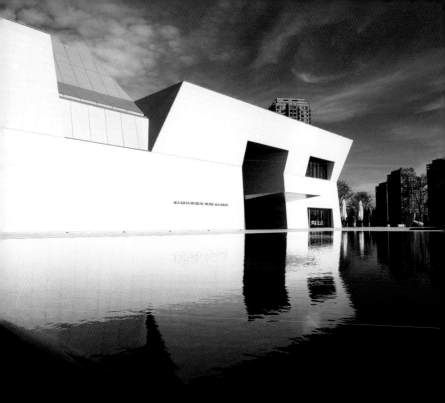

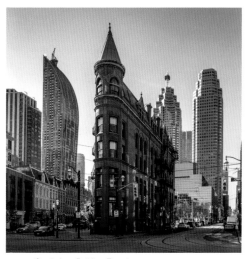

ABOVE: Gooderham Building, Toronto

LEFT: Aga Khan Museum, Toronto

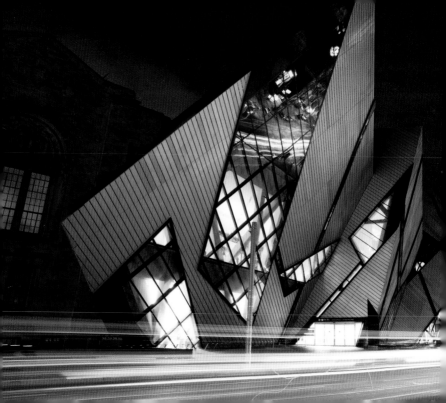

Michael Lee-Chin Crystal,
Royal Ontario Museum, Toronto

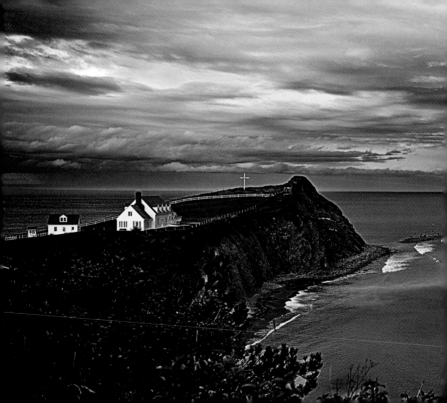

Quebec

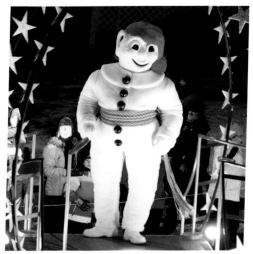

ABOVE: Bonhomme, Quebec Winter Carnival

RIGHT: Quebec City

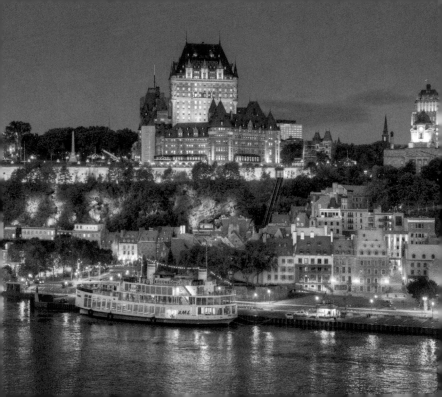

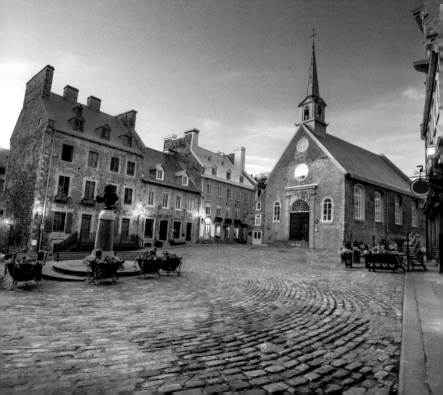

ABOVE: Rue du Cul-de-Sac, Quebec City

LEFT: Petit-Champlain District, Quebec City

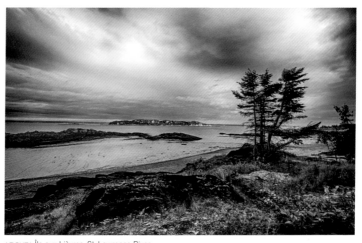

ABOVE: Île aux Lièvres, St. Lawrence River

RIGHT: White-tailed deer in Omega Park, Montebello

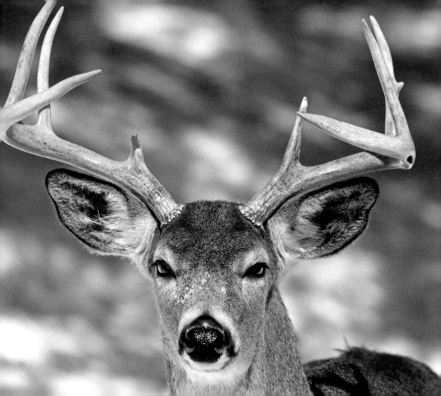

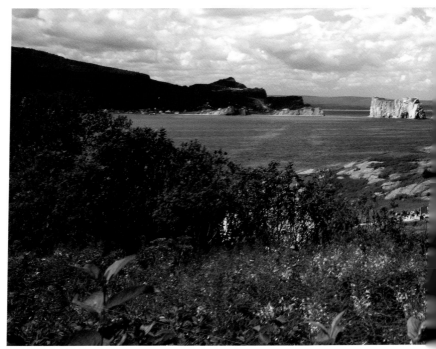

Bonaventure Island

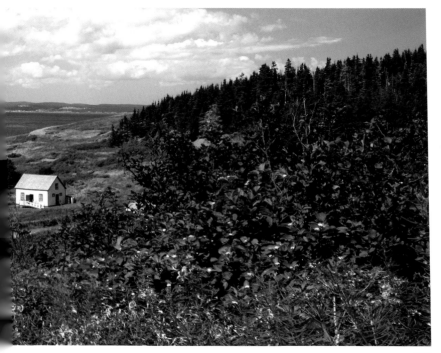

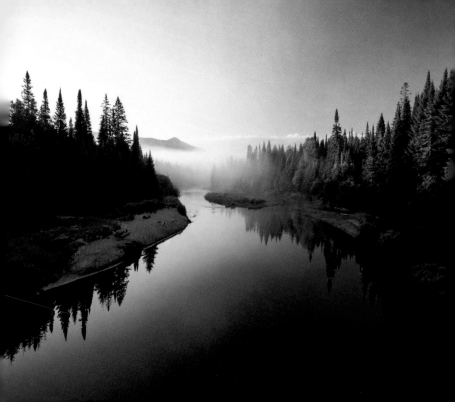

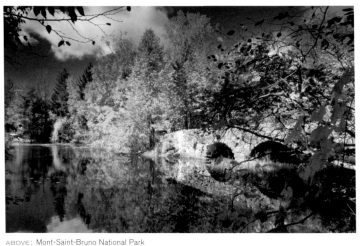

ABOVE: Mont-Saint-Bruno National Park

LEFT: Devil's River, Mont-Tremblant National Park

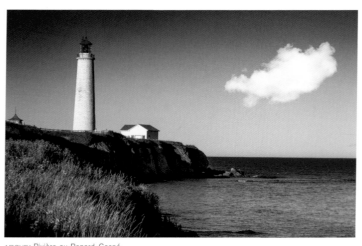

ABOVE: Rivière-au-Renard, Gaspé

RIGHT: Ungava Bay

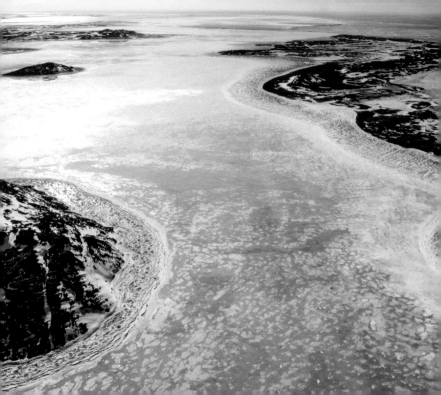

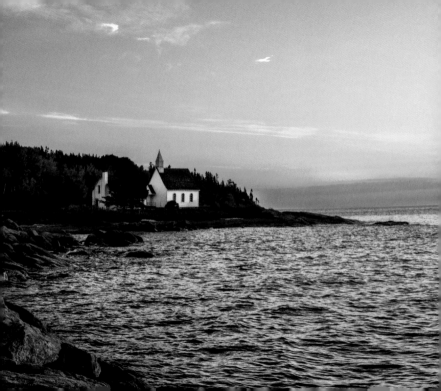

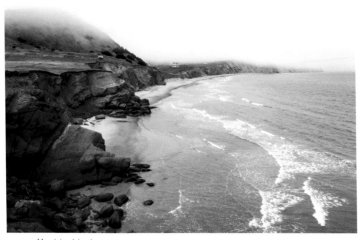

ABOVE: Magdalen Islands

LEFT: Port-au-Persil

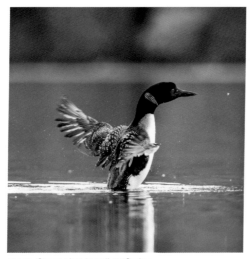

ABOVE: Common loon in northern Quebec

RIGHT: Maple syrup tapping

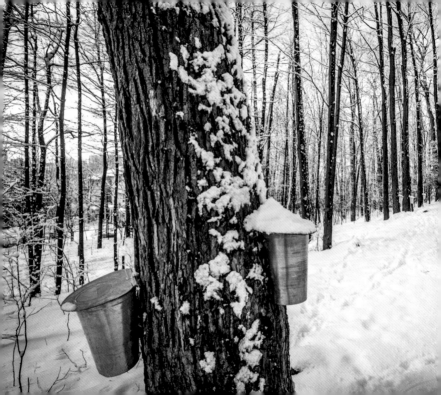

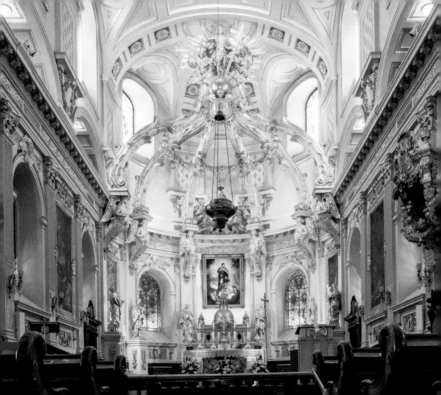

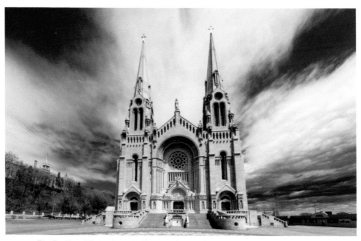

ABOVE: The Basilica of Saint-Anne-de-Beaupré, Quebec City

LEFT: Interior of the Notre Dame Basilica, Quebec City

223

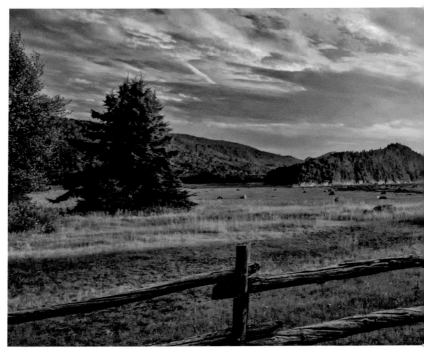

Bic National Park

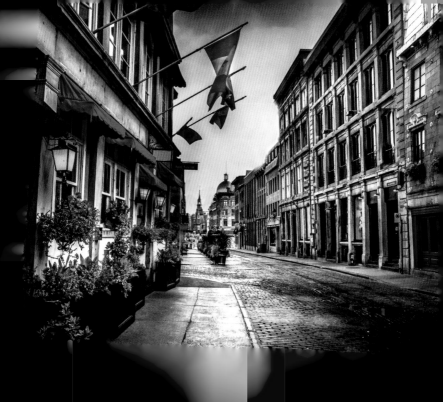

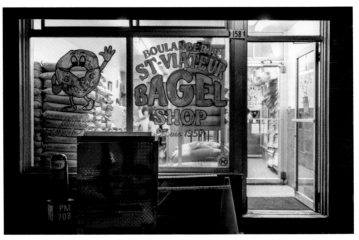

ABOVE: St-Viateur Bagel shop in the Mile End

LEFT: Old Montreal

227

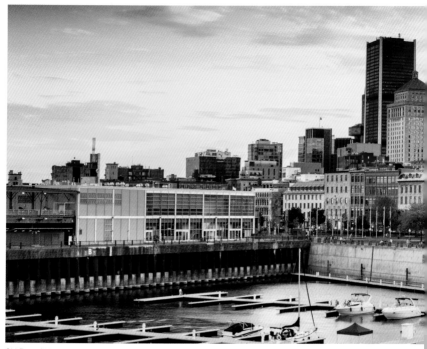

Old Port of Montreal on the St. Lawrence River

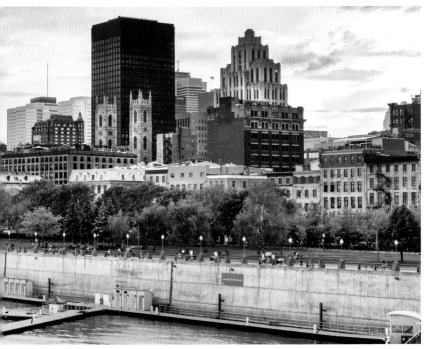

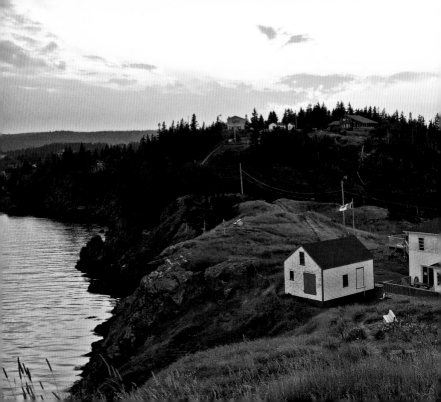

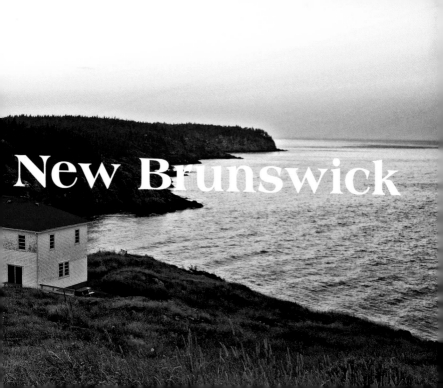

New Brunswick

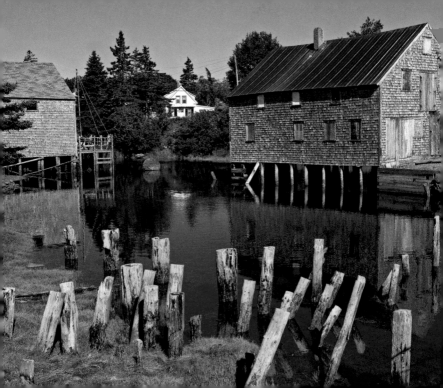

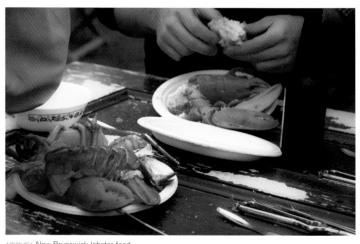

ABOVE: New Brunswick lobster feed

LEFT: Seal Cove, Grand Manan Island

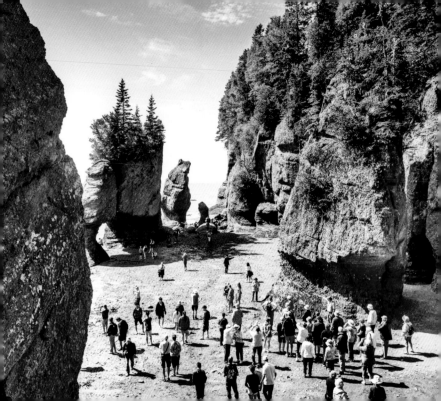

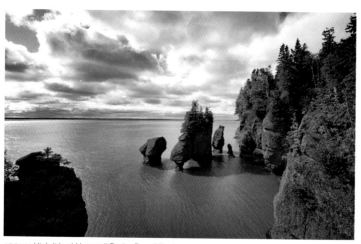

ABOVE: High tide at Hopewell Rocks, Bay of Fundy

LEFT: Low tide at Hopewell Rocks, Bay of Fundy

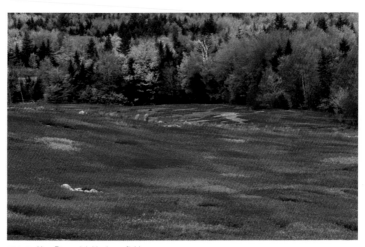

ABOVE: New Brunswick blueberry field
RIGHT: Hartland Bridge, Saint John River

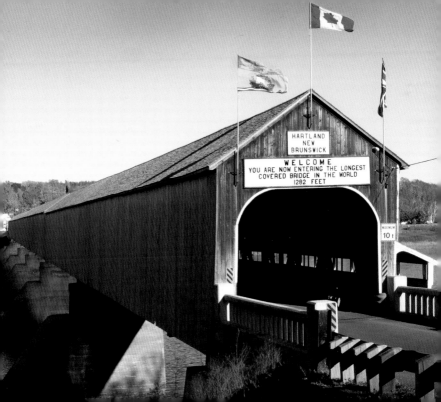

HARTLAND
NEW
BRUNSWICK

WELCOME
YOU ARE NOW ENTERING THE LONGEST
COVERED BRIDGE IN THE WORLD
1282 FEET

MAXIMUM
10 t

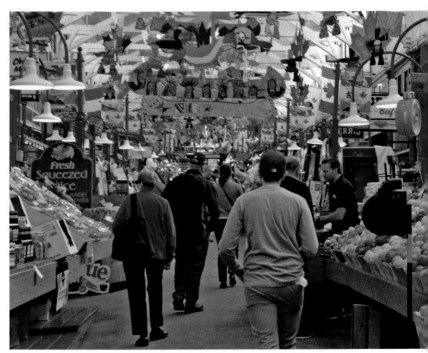

Saint John City Market

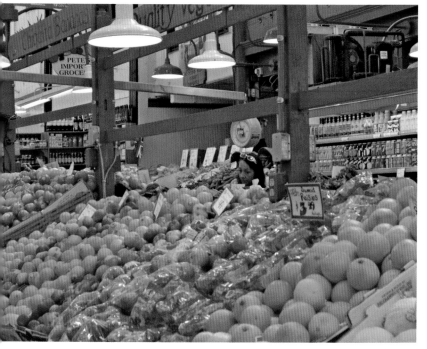

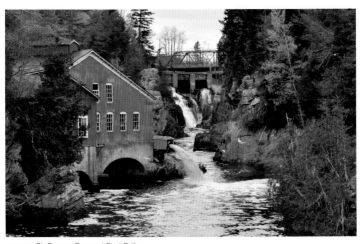

ABOVE: St. George Gorge at First Falls

RIGHT: Harbor seals in St. Andrews by-the-Sea

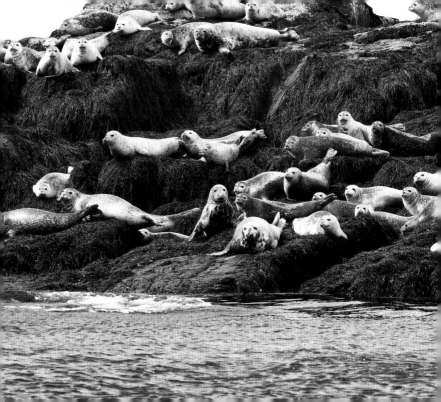

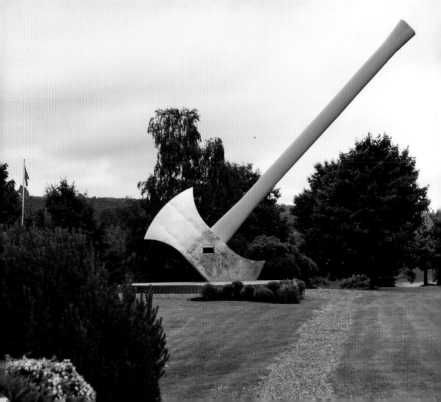

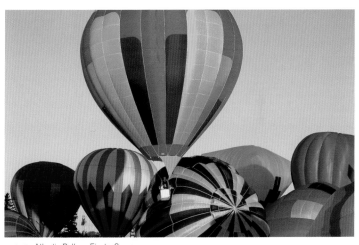

ABOVE: Atlantic Balloon Fiesta, Sussex

LEFT: World's Largest Axe, Nackawic

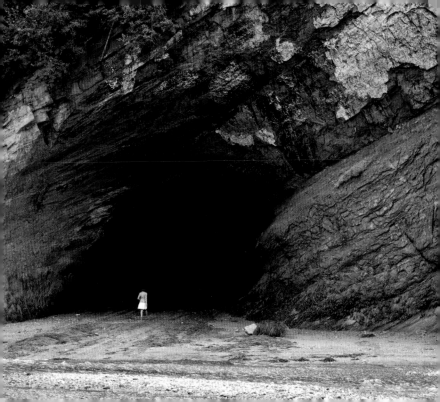

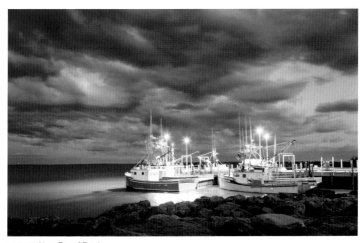

ABOVE: Alma, Bay of Fundy

LEFT: St. Martins Sea Caves, Bay of Fundy

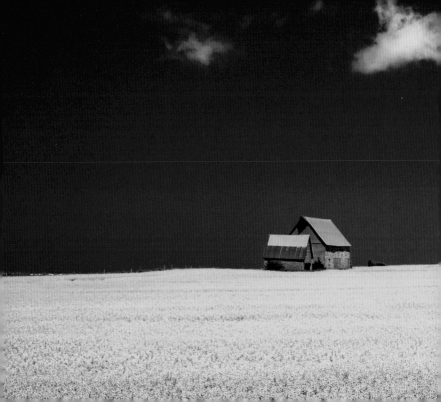

Prince Edward Island

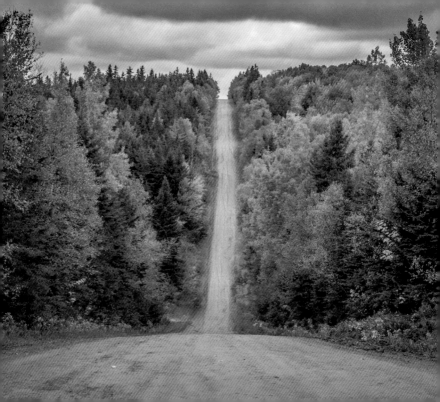

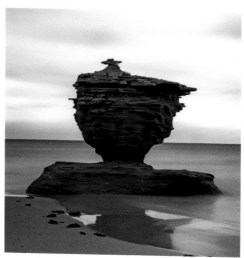

ABOVE: Teacup Rock, Thunder Cove Beach

LEFT: St. Patrick's Road, New Glasgow

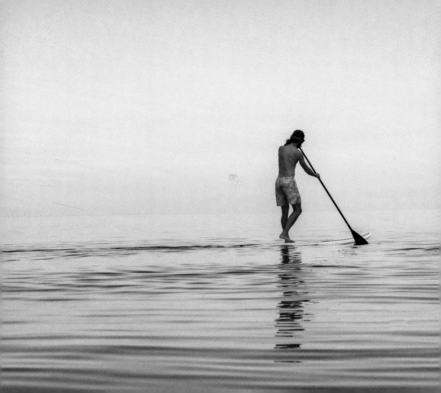

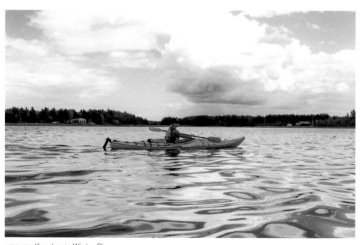

ABOVE: Kayaker in Winter River

LEFT: Paddle boarder at Darnley Basin Beach

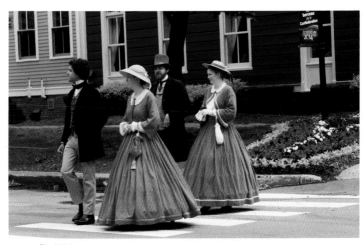

ABOVE: Charlottetown

RIGHT: Bellevue Cove

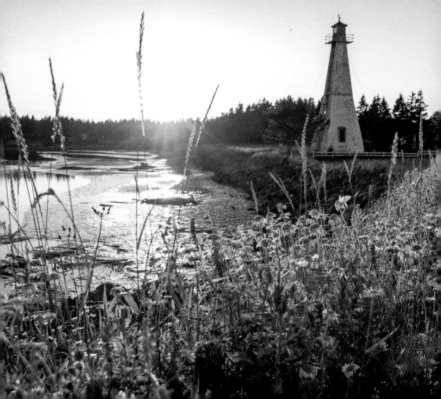

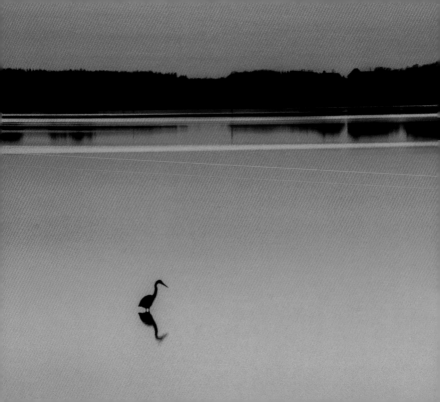

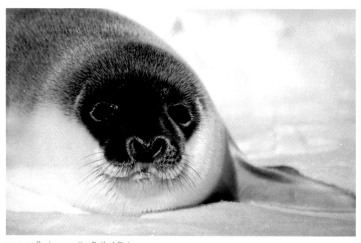

ABOVE: Seal pup on the Gulf of St. Lawrence

LEFT: Great blue heron in Covehead Bay

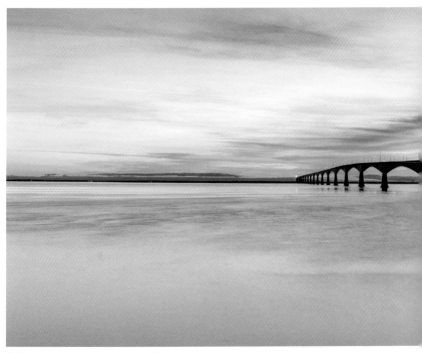

Confederation Bridge, Marine Rail Historical Park

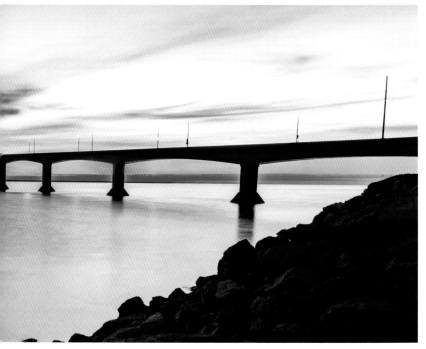

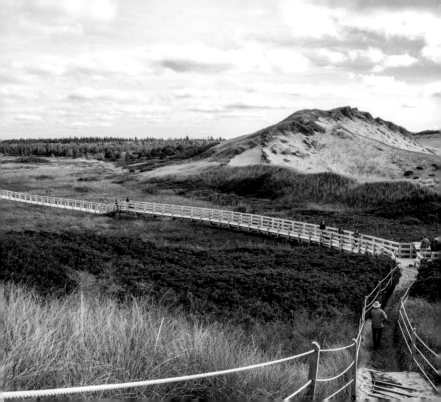

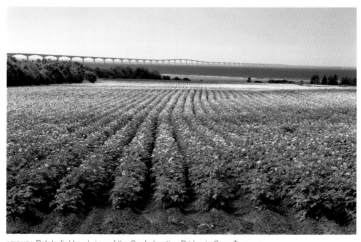

ABOVE: Potato field and view of the Confederation Bridge in Cape Traverse

LEFT: Greenwich National Park

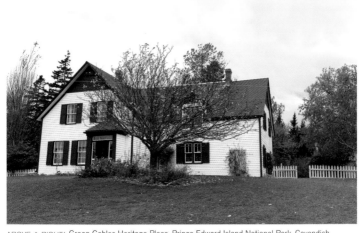

ABOVE & RIGHT: Green Gables Heritage Place, Prince Edward Island National Park, Cavendish

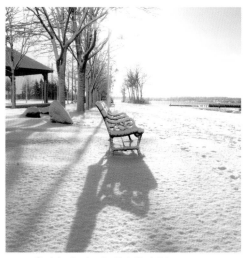

ABOVE: Confederation Landing Park, Charlottetown

RIGHT: Brighton

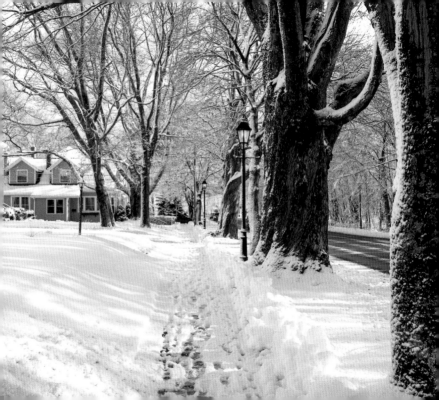

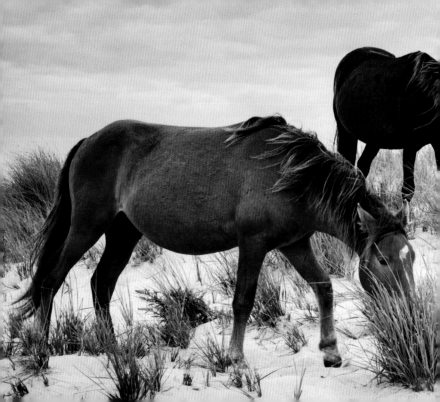

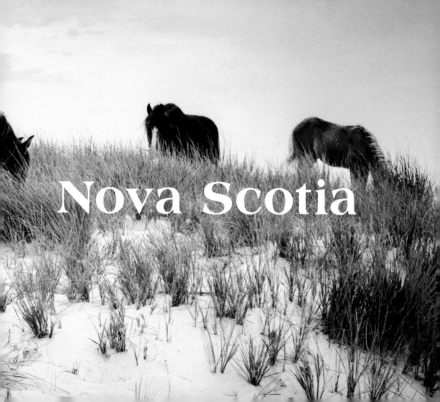

Nova Scotia

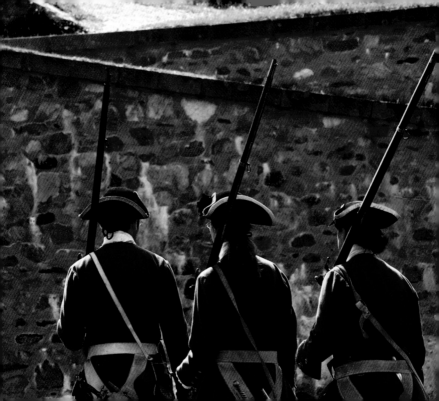

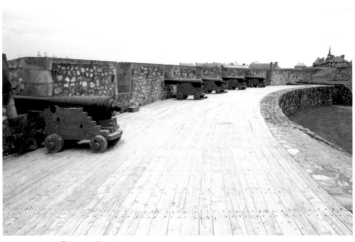

ABOVE & LEFT: Fortress of Louisbourg

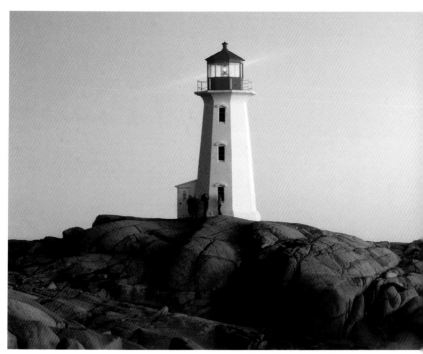

Peggy's Point Lighthouse, Peggy's Cove

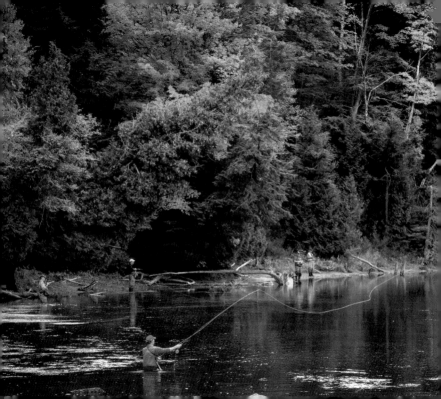

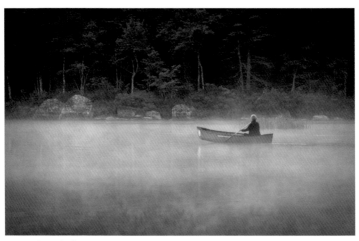

ABOVE: Annapolis County

LEFT: Sable River

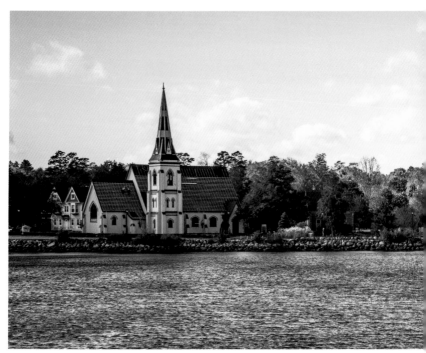

Mahone Bay

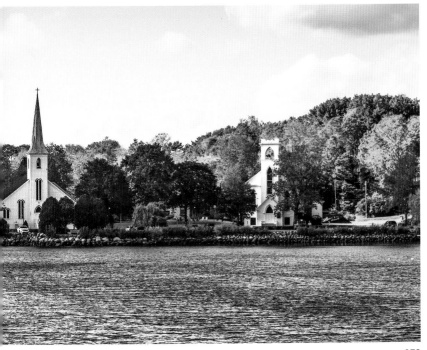

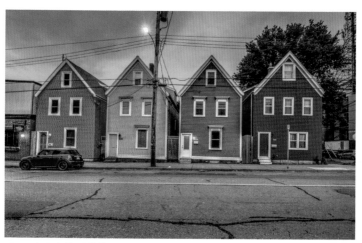

ABOVE: Agricola Street, Halifax

RIGHT: Blue Rocks

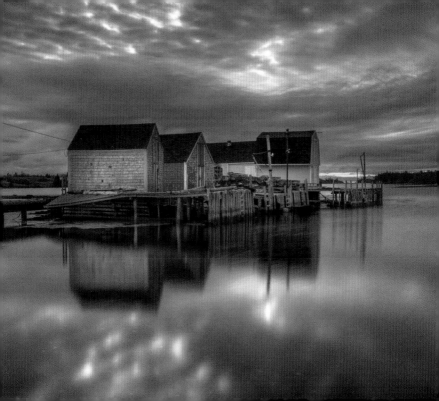

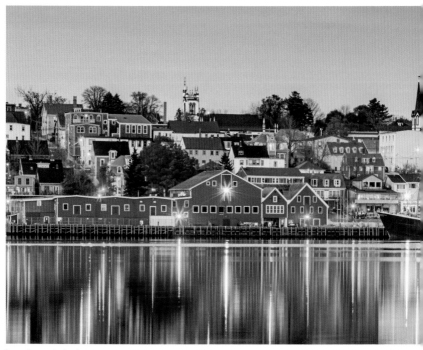

Lunenburg waterfront

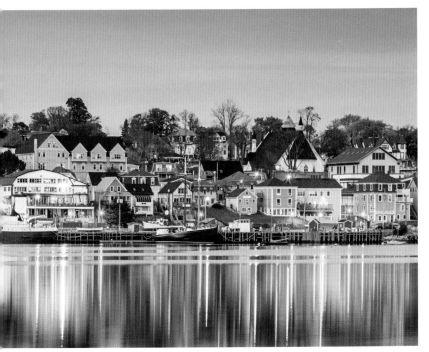

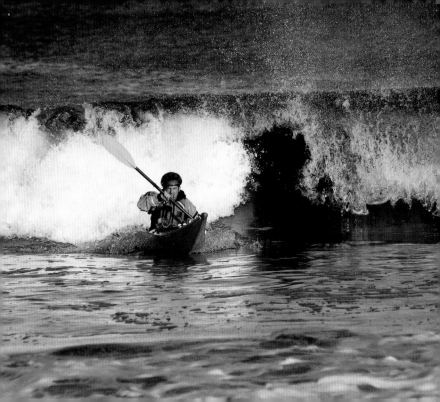

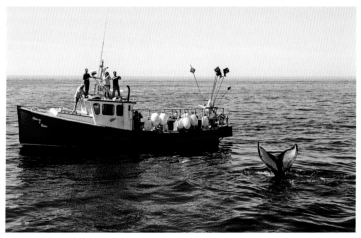

ABOVE: Whale watching in the Bay of Fundy

LEFT: Kayaker at Black Cove

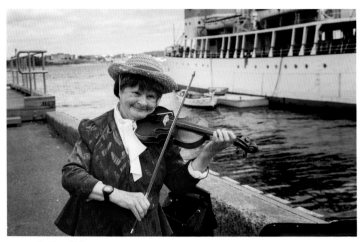

ABOVE: Maritime fiddler

RIGHT: *Theodore Too* tugboat in Halifax Harbour

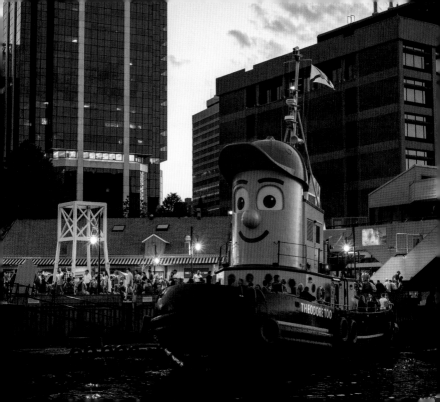

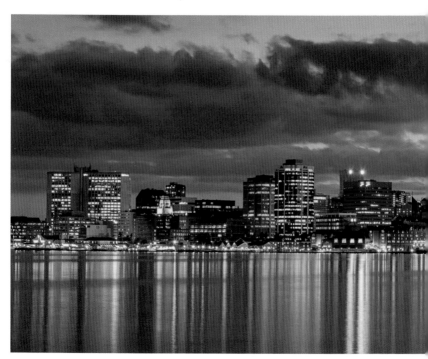

Halifax waterfront

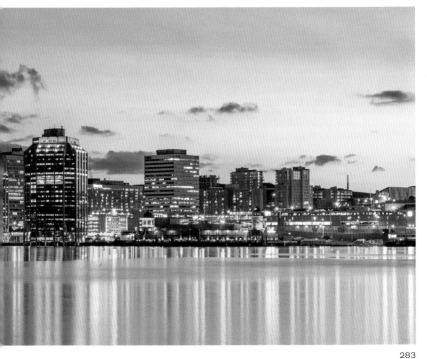

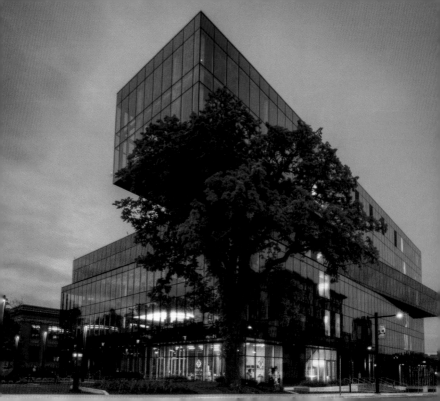

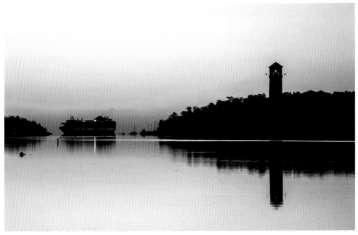

ABOVE: Northwest Arm, Halifax Harbour

LEFT: Halifax Central Library

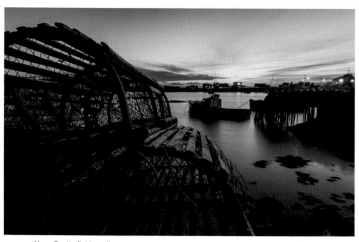

ABOVE: Nova Scotia fishing village

RIGHT: Cabot Trail, Cape Breton Island

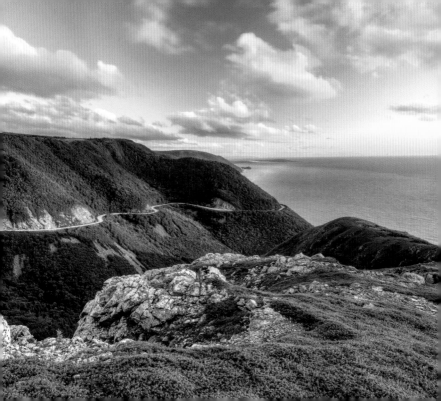

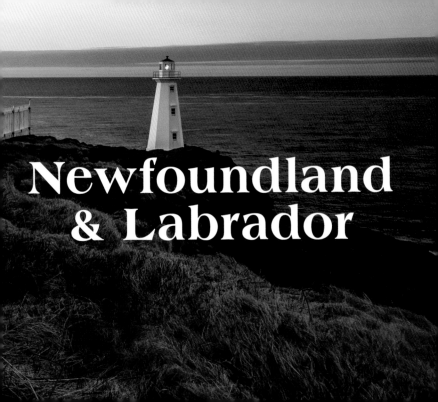

Newfoundland & Labrador

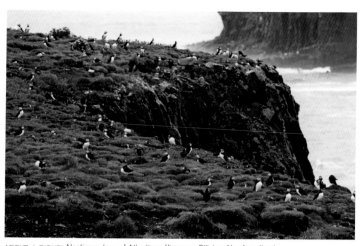

ABOVE & RIGHT: Nesting colony of Atlantic puffins near Elliston, Newfoundland

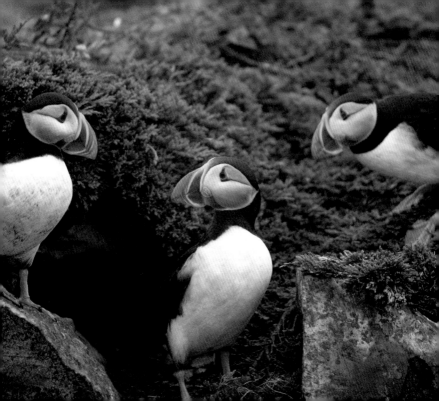

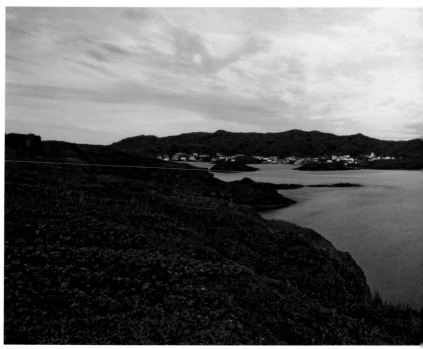

Iceberg off Goose Cove, Newfoundland

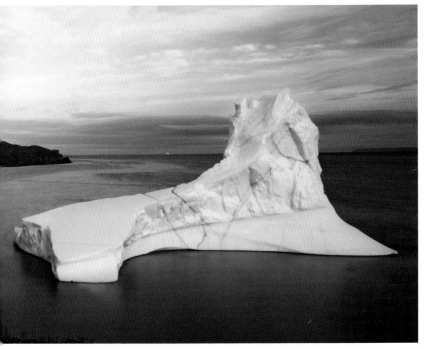

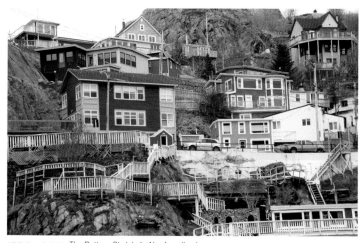

ABOVE & RIGHT: The Battery, St. John's, Newfoundland

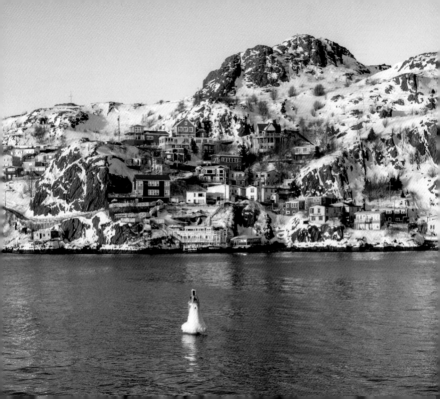

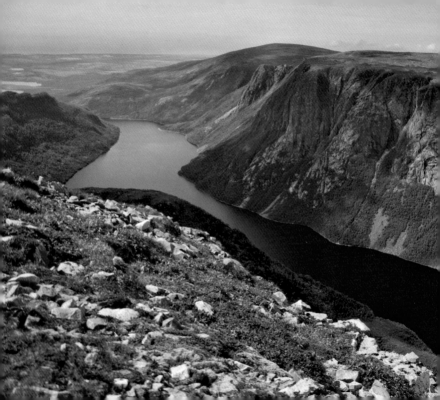

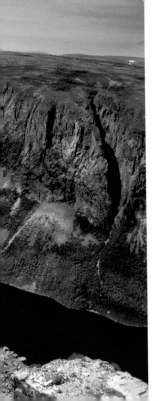

Gros Morne National Park, Newfoundland

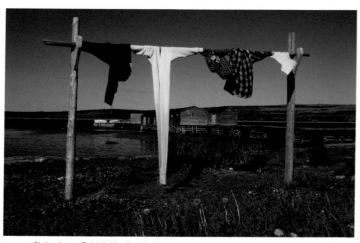

ABOVE: Clothesline in Raleigh, Newfoundland

RIGHT: Norris Cove in Bonne Bay, Newfoundland

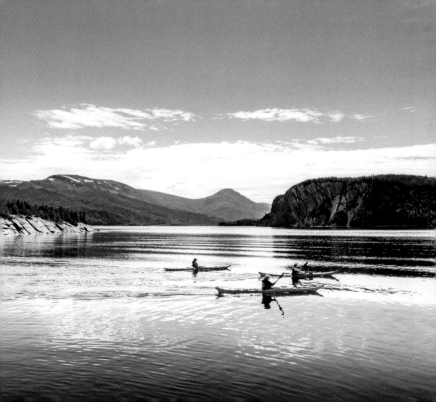

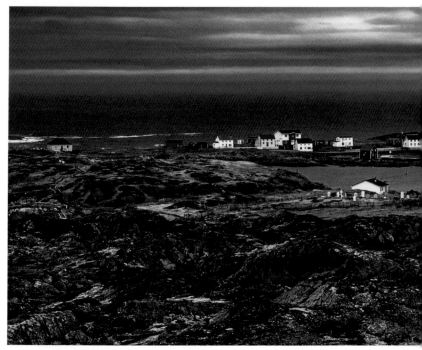

Tilting, Fogo Island, Newfoundland

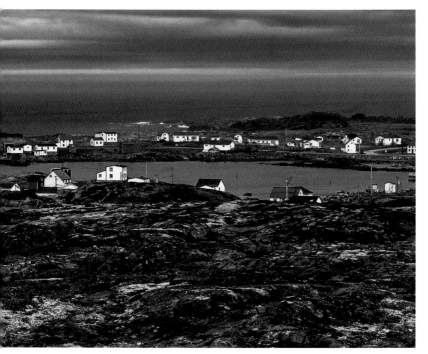

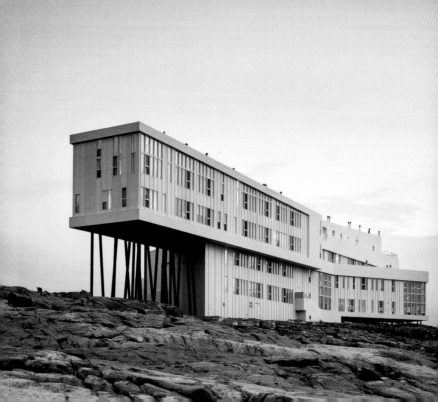

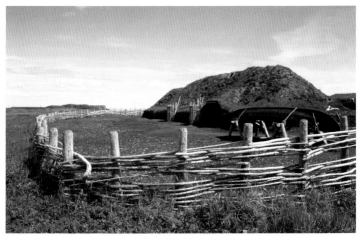

ABOVE: L'Anse aux Meadows National Historic Site, Newfoundland

LEFT: Joe Batt's Arm, Fogo Island, Newfoundland

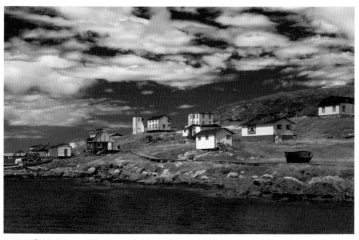

ABOVE: Battle Harbour, Labrador

RIGHT: Pinware River, Labrador

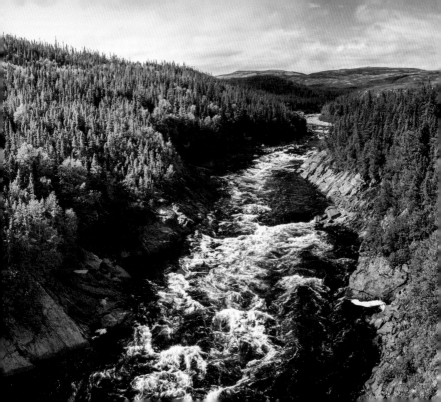

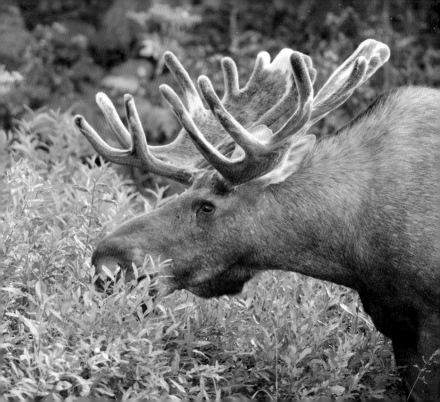

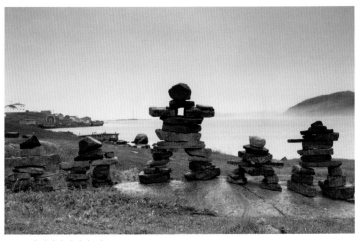

ABOVE: Inukshuks in Labrador

LEFT: Bull moose in northern Newfoundland

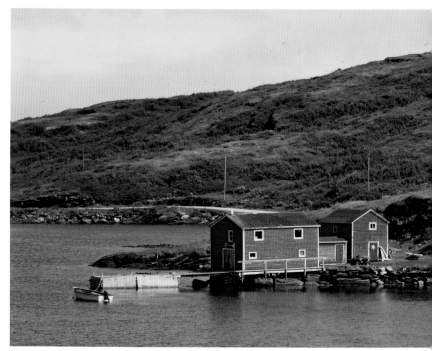

Fishing village on White Cape Harbour, Newfoundland

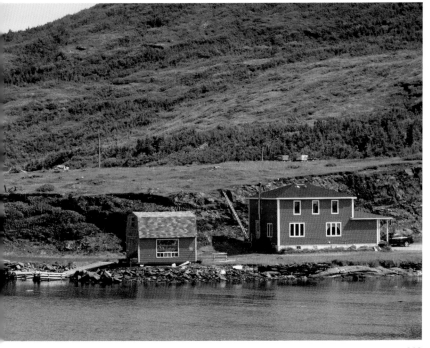

Canada
Copyright © 2019 HarperCollins Publishers Ltd.
All rights reserved.

Published by Collins, an imprint of HarperCollins Publishers Ltd

First edition

All photography courtesy iStockphoto.com except as noted in the
photography credits section on page 312.

HarperCollins books may be purchased for educational, business,
or sales promotional use through our Special Markets Department.

HarperCollins Publishers Ltd
Bay Adelaide Centre, East Tower
22 Adelaide Street West, 41st Floor
Toronto, Ontario, Canada
M5H 4E3

www.harpercollins.ca

Library and Archives Canada Cataloguing in Publication
information is available upon request.

ISBN 978-1-4434-5850-4

Printed and bound in China
PP 10 9 8 7 6 5 4 3 2 1

Photography Credits

Cory Beatty | @corybeatty
Pages 54–55; 249; 260; 274; 284; 288–89

Tony Beck | @always_an_adventure_inc
Pages 108–9; 115; 121; 170; 185; 191; 211

Bloomberg/Getty Images
Page 88

André Brandt | andrebrandt.com
Pages 158; 168–69; 172; 176; 177

Stéphane Caron | @stephanecaron88
Pages 138; 140–41; 142; 143; 144; 145; 152; 210;
212–13; 215; 216; 217; 224–25; 255

Julio Castro Pardo | @juliocastropardo
Page 61

Raymond Gehman/National Geographic Collection/
Getty Images
Page 87

Lowell Georgia/Getty Images
Page 86

Leah A. Horstman | lahorstmanphotography.com
Pages 5; 21; 68; 69; 72–73; 78

Mark Jinks | markjinksphotography.com
Pages 11; 14; 56; 60; 66–67; 110; 111; 114; 180; 181

Lans Photography | @lansphotography
Pages 209; 248; 250; 251; 253; 254; 258; 262; 263

Florian Ledoux | florian-ledoux.com
Pages 128–29; 132; 133; 146–47; 148; 149; 150; 151; 153

Wayne Lynch/Getty Images
Page 89

Leo MacDonald | @leomacdonaldphoto
Pages 178–79; 186; 207; 270; 271; 275; 285

John E. Marriott | wildernessprints.com
Pages 2–3; 4; 6–7; 9; 15; 23; 28–29; 32–33; 36–37; 47;
50; 51; 58–59; 64; 70; 71; 74; 75; 77; 79; 80; 104–5;
106; 117; 118–19; 120; 130; 131; 136; 137; 154–55;
156–57; 171; 290; 291; 292–93; 308–9

Christopher Martin | christophermartinphotography.com
Pages 16; 30; 31; 57; 214

Anna Mawdsley | @brixtonphotog
Pages 159; 160; 161

Paul Nicklen/National Geographic Collection/Getty Images
Page 17

RyersonClark/Getty Images
Page 90

Nina Stavlund | alwaysanadventure.ca
Pages 184; 188; 189; 192–93; 230–31; 232

Andrea van Ogtrop | vanogtropphotography.com
Page 198

Don Wilson | @wilson.images
Pages 84–85; 116

The following images are not provided with a caption on the pages on which they appear.

Page iii: Moraine Lake in the Valley of the Ten Peaks, Banff National Park

Page iv: Canada geese on Lake Ontario

Page vi: Earl Marriott Secondary/Semiahmoo First Nation Pow Wow in White Rock

Pages 2–3: Mount Assiniboine Provincial Park

Pages 32–33: Tombstone Territorial Park

Pages 54–55: Vermilion Lakes, Banff National Park

Pages 82–83: Aerial view from a seaplane of Nahanni National Park Reserve

Pages 104–5: Wheat field near Leader

Pages 128–29: Fjords east of Baffin Island

Pages 156–57: Hudson Bay Lowlands, Churchill

Pages 178–79: Sauble Beach

Pages 204–5: Percé Rock, Gaspé Peninsula

Pages 230–31: Swallowtail Lightstation, Grand Manan Island

Pages 246–47: Prince Edward Island mustard field

Pages 264–65: Wild horses on Sable Island

Pages 288–89: Cape Spear Lighthouse National Historic Site

Page 314: North American beaver in Ontario

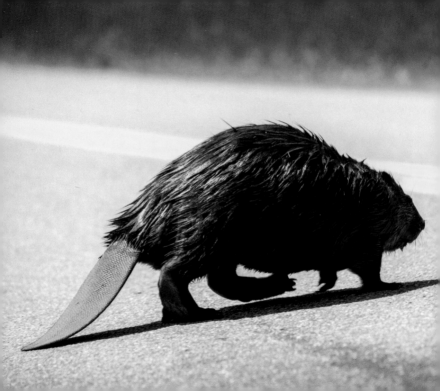